B N C V N

O N V S

K C S V D

K H Z C K

R Z R

C Z S H N

H C O H V C K

Z D S N C V K D C Z S H N O

H Z C K O N C K H D Z H C S R S Z R D N H C

H Z C K O N C K H D Z H C S R S Z R D N H C D R O H V Z D S

BY TEJU COLE

BLIND SPOT

KNOWN AND STRANGE THINGS

EVERY DAY IS FOR THE THIEF

OPEN CITY

BLIND
SPOT

Z D S

N C V K D

$\frac{6}{30} \frac{20}{100}$ —— # BLIND —— $\frac{20}{100} \frac{6}{30}$.20 0.7

SPOT

C Z S H N

$\frac{6}{15} \frac{20}{50}$ —— # TEJU —— $\frac{20}{50} \frac{6}{15}$ 40 0.4

COLE

Z K C S V

D V O H C

O H V C K

FOREWORD BY SIRI HUSTVEDT

RANDOM HOUSE NEW YORK

Copyright © 2016, 2017 by Teju Cole
Foreword copyright © 2017 by Siri Hustvedt

Published in the United States by Random House, an imprint and division of
Penguin Random House LLC, New York.

RANDOM HOUSE and the HOUSE colophon are registered trademarks of
Penguin Random House LLC.

Some of the photos in this edition were originally published in *Punto d'ombra*
by Teju Cole (Rome, Italy: Contrasto Books, 2016).

Text permission credits are located on pages 331–32.

Library of Congress Cataloging-in-Publication Data
Names: Cole, Teju.
Title: Blind spot / Teju Cole.
Description: New York : Random House, 2017
Identifiers: LCCN 2016032505 | ISBN 9780399591075 (hardback) |
ISBN 9780399591082 (ebook)
Subjects: LCSH: Travel photography. | International travel. | Cole, Teju—Travel.
Authors—United States—Travel. | African American authors—Travel.
Classification: LCC TR790 .C65 2017 | DDC 770—dc23
LC record available at https://lccn.loc.gov/2016032505

Printed in China on acid-free paper

randomhousebooks.com

2 4 6 8 9 7 5 3 1

First Edition

Book design by Liz Cosgrove

For Madhu
& for John

Siri Hustvedt

Inside each human eye and the eyes of other vertebrates, there is a blind spot where the retina meets the optic nerve. This area, the optic disc, is insensitive to light and receives no visual information. Every person should therefore experience a significant blind spot in her or his visual field—about the size of an orange held at arm's length. And yet, normally sighted people do not walk around with holes in their vision. Somehow the absence is filled. The unanswered question is: How? The hypotheses vary, and they depend on a larger understanding of the human organism and its relation to what lies beyond its skin. There are ongoing arguments about whether we see the world directly or whether we see an internally generated representation of the world. The arguments on either side are complex, nuanced, unresolved, and, depending on how you frame the problem, not necessarily contradictory.

There is considerable evidence, however, that perception is not purely passive—that we not only take in the world, we also make it, and that learning is part of that creativity. Experience establishes patterns of repetition, and those repetitions become recognitions that in turn generate predictions about the world. Sometimes our predictions fail, and we are surprised. Every human being has had moments when the familiar is rendered suddenly strange or one thing is mistaken for another. I once walked toward my own reflection, fully convinced it was another person. My error was the result of my disorientation in space, which in turn disrupted my expectations about what was what and, in this case, who was who.

Such delusions prompt philosophical as well as physiological questions. What is seeing? What is inside the looking person and what is

outside him? How do we parse what we see? "We see the world," Teju Cole writes in this book. "This simple statement becomes . . . a tangled tree of meanings. Which world? See how? We who?" In the photo that accompanies the text, I see the nose of a red car parked behind a white van against a white wall. On the van is an enlarged photograph of a classroom with a few students in orange uniforms working quietly at their desks. I look into the recesses of that room and know I am seeing an illusion of depth on the vehicle's nearly flat surface. Because the image is not a painting, I also know that the room existed somewhere at some time, but that place is elsewhere. I am seeing a photograph inside a photograph, a world within a world, but also an uncanny displacement of one space with another. And then I have the further thought: the van, not its representation, but the one that exists in the world, carries that image of a classroom along with it on the road.

By the time I reached the words "We see the world" and the corresponding image taken in São Paulo in March 2015, I had arrived on page 273 of this book, and I had already circled the globe. "Teju Cole really gets around," I said to myself. In three years, he has ricocheted from Seoul to London to Lagos to Capri to Selma, among many other destinations. I had to look up the names of some of the towns he mentions and locate them on the map to orient myself. Teju Cole jets from city to city. Teju Cole explores one outpost after another, and Teju Cole punctuates these flying leaps with visual and written records. The camera's eye is not the human eye. The camera takes in everything inside its frame. We do not. Human beings have poor peripheral vision. Details vanish because we cannot focus on everything at once. Sequences blur. We pay attention to what is most salient for us—a donut takes on a charm when we are hungry that it doesn't have when we are not hungry. We are prone to cultural biases. They vary from place to place, are notoriously stubborn, and are often unconscious. Sexism and racism are born of skewed perceptions, of overvaluing masculinity and whiteness and treating them as absolute categories, which they are not. We, all of us, are prone to these debilitating forms of blindness.

When the shutter clicks, the world stops in a frame. Once they have

been written, words, too, are fixed. And yet, pictures and words are dormant until they are seen and read. I, the viewer-reader, animate the book, and, as long as I am alive, I am a body in motion. The book's rhythm is established from its first sentence and its first photograph. It is the rhythm of a peripatetic philosopher, the itinerant thinker who puts one foot in front of the other. The body's kinetic music is not separable from thoughts or their metaphors. The feet move, and mental connections are made step by step. "There is a secret tie or union among particular ideas, which causes the mind to conjoin them more frequently, and makes the one, upon its appearance, introduce the other," wrote David Hume. But the steps made in this book are not those of deductive or inductive logic. I follow a meandering, not a straight, path, one that branches into many paths, paths that then cross and recross over the course of my journey through the book.

From the beginning, I read and I look. I find "a tangled tree of meanings" between text and image, a metaphorical wood. On the first page, I am in New York State, a small town called Tivoli. In the photograph, I see the shadows of a tree's bare branches that sprout into a road. Beyond that road, I see a hedge with its first fuzz of tiny leaves. A white house rises beyond the hazy hedge-screen. I begin to read, "Spring, even in America, is Japanese." Really? That's a surprising sentence. But when I look at the photograph, the tree's shadow evokes the countless images of branches in Japanese art, usually in full spring flower. (Here the blossoms are implied by the association but are absent from the image.) Spring, the time of birth, of bloom, of stirring motion.

"It is not only the leaves that grow," Cole writes. "Shadows grow also. Everything grows, both what receives the light, and what is cast by it." This light and the lengthening shadows it creates are followed by a simile—the "more" of the world "proliferating like neural patterns." I am taken from one scale to another, from tree shadows in a road to the brain hidden inside my skull with its billions of tiny neurons and their branching axons and dendrites. Next, I read that spring is "the most melancholy season" and am hurtled back to Sparta in the seventh century and to the words of the poet Alkman, who worried about food. Alk-

man's poetry consists of fragments, word rubble from a vanished age: "[?] made three seasons, summer / and winter and autumn third / and fourth spring when / there is blooming but to eat enough / is not."

Cole writes, "Resurrection is far too close to death." The word "resurrection" summons the Christian story and the Passion of Christ. I imagine the women who arrive at the tomb and find it empty because the dead man has come back to life. But the word has pushed my thoughts and mental imagery beyond the immediate text. The reference to resurrection here is to the ambiguous border between the deadness of winter and the rebirth of spring, which is instantly followed by eyes opening after sleep.

Then I recognize the name of a film: *Sans Soleil*. I have seen it, and I smile. Chris Marker, the filmmaker, was another man who circled the globe and made a film about his travels. Important sequences take place in Japan. One of the earliest lines in the film, spoken by an invisible woman, is this: "He wrote, 'I've been around the world several times, and now only banality still interests me.'" The documentary is a philosophical meditation on memory, time, space, and vision. The woman who narrates the film talks about the letters written to her from a filmmaker, Sandor Krasna, a fictional mask or pseudonym for Marker. (It is good to remember that in the history of literature and philosophy, such masks sometimes take on lives of their own.) The movie leaps from Iceland to Japan to Guinea-Bissau to San Francisco. Cole's text ends with a story told in the film. A man loves a woman who dies. After she dies, he "drowns" himself in work, and in May he kills himself. "They say he could not stand hearing the word 'Spring.'"

One paragraph of text and a single photograph have generated a host of flowering images, thoughts, and references. Some of the mental "ties" are apparent; others are veiled or masked—there to be found if one cares to look, but if one doesn't look and doesn't read closely, if one doesn't take time to uncover what lies in, between, and beyond the words and pictures, one will be blind to their meanings. The tree that casts its shadow is not inside the frame of the photograph. Alkman's fragment is referred to but is not quoted in the text. The cycling of the seasons, sleeping and waking, dying and being born, presence and ab-

sence, and the blurred border between one and the other open *Blind Spot*.

The allusion to *Sans Soleil* is not then merely to the story of a suicide in the spring in Japan but to the movie as a whole, to what is, in fact, *missing* from Cole's text and image. The film is not a chronological documentary report on a man's travels. The movie quickly establishes patterns that do not obey sequential logic. It is not organized according to proximal spaces either; the periphery is as important as the center. Cole's homage to Marker is an announcement of his book's form, his own invisibility, and his subject matter. The film audience never sees Marker/Krasna. We listen to another person read his letters.

The reader-viewer does not see Teju Cole either. I read his silent letters in the voice of my own internal narrator and look at his images on the page. There is only one "selfie" in this book, and it is never taken. The wish to take it occurs in a dream, another shadow realm. After he wakes up, the writer remembers his desire for a picture of himself with Princess Diana, who is alive in the dream but long dead in the world. Krasna's declaration that only banality interests him lurks behind the reference too. Cole writes that he is not interested in tourist sites. In fact, he avoids them. The photographs in this book have little to do with the glossy and gorgeous scenic images that weigh down coffee tables all over the world. They are not idealized "art" photos either. They emphasize the *pedestrian*.

I leave one page and turn to the next, and with each new leaf, I locate "a tie or union among particular ideas," as Hume put it, an association by word or picture that carries me along further and further into the book. It turns out that my fantasy of the women at Christ's tomb prompted by the word "resurrection" anticipated a recurring theme of the dead, tombs, the cross, and graves, as well as what is hidden and what is seen. Everyone walks on the dead because we walk on the earth. The author tells us he has lost his faith. As a boy he believed, and then the world looked different. Religious faith creates an order to vision that vanishes without it. As a child I believed in angels, those winged messengers between heaven and earth. They figure strongly in Cole's text as liminal figures that cross boundaries and defy the laws of gravity,

as insubstantial or substantial as human wishes, hallucinations, and dreams.

The shroud of the Christian bible story mutates into multiple forms—the white cloth that receives the body of Christ as it is lowered from the cross and the rags left in the empty tomb become other materials, represented in words and pictures, materials that catch the light or billow in the wind, that cloak bodies and buildings and cars. But there are also references to the draperies depicted in Renaissance and Baroque painting, an artist's proof of skill, but also a testament to visual ideas in which the neat boundaries between inside and outside collapse in the fold.

As I move through the book, I shuttle from concrete image to abstract thought. I see a ladder in a photograph before I read the word "ladder" on the following page. The ladders lead me up and down. I climb with Jacob. I fear falling with the author and, with him, I recall the ladder in Dante's *Divine Comedy* and see it again in my mind's eye.

Greek myths and stories circle through the text—Agamemnon's death, Hermes's winged feet, Oedipus's scarred feet and self-inflicted blindness. Feet fly, hobble, and limp through this peripatetic volume. A mysterious photograph of two tubes, one beside the other, resembles a pair of legs. Eyes open and close. Eyes see, go blind, and are closed in death. One myth, one story, connects to other stories and to pictures, both in the book itself and in the minds of the people who hold the book in their hands. Images created by dead artists are conjured in language: Caravaggio, Dürer, Degas, Hitchcock. Dead poets speak: Theodore Roethke, Seamus Heaney, Gerard Manley Hopkins, and Kofi Awoonor, the Ghanian poet who was shot by terrorists in the Westgate Mall in Nairobi in 2013, close to where Teju Cole was staying, a horrifying conflation of space and time, a collision of chance and vicious ideology.

Monstrous acts committed then and now in the name of ideas are omnipresent—witch-burning; the crimes of the Ku Klux Klan; the genocide of Hitler's National Socialism; the abuse of impoverished "contract" children in Switzerland, Verdingkinder, who were taken from their homes and forced to work on farms; the mass murders in Indonesia, which remain unrecognized by the regime; 9/11 in New York City; the brutality of ISIS; the murders of black men by police in the United States;

men going from Lebanon to Syria to fight. These bloody events are not seen in the pictures. Cole is on his way to a demonstration for Black Lives Matter. He takes a photograph: five folding chairs squeezed between a vehicle and a fire hydrant. Do not be mistaken: protest and outrage simmer in these pages like a pot on low boil.

On one page, I read that the great abolitionist born into slavery, Sojourner Truth, sold photographs of herself. "I Sell the Shadow to Support the Substance," she said. Cole's photos are shadows, too, of things that may or may not exist anymore and of moments that will never be repeated. After Sojourner Truth's sentence, I find the last three lines of a poem by Tomas Tranströmer, a poet I know well: "but often the shadow seems more real than the body. / The samurai looks insignificant / beside his armor of black dragon scales." The poem is "After a Death." The second stanza, not in Cole's text, is as important as the lines that are quoted:

One can still go slowly on skis in the winter sun
through brush where a few leaves hang on.
They resemble pages torn from old telephone directories.
Names swallowed by the cold.

The few remaining leaves on winter trees merge with names, lists of the many now dead, who are no longer substances but signs only. The elegy replaces the body that has disappeared and the words become *more real*. The stanza is literally a blind spot in *Blind Spot*, an absence I must fill in, as the mind fills in the empty space in the visual field.

One morning in 2011, Teju Cole woke up blind in one eye. He suffered from papillophlebitis, perforations to his retina. The disappearance of sight in one eye makes depth perception impossible, and Cole informs the reader that he had trouble walking. Space changes if you can't see its extensions. It is not so easy to put one foot in front of the other. A person's gait, the rhythm of his steps must change to accommodate his altered vision, but inevitably there is a corresponding wrench in thought. Cole had surgery to correct the retinal tears and afterward was uncertain about his sight for a period of months during the winter. He writes,

"The photography changed after that. The looking changed." A reorientation became necessary.

"Because we are in the world," Maurice Merleau-Ponty wrote in his preface to the *Phenomenology of Perception*, "we are condemned to meaning." Merleau-Ponty is alluded to twice in *Blind Spot*. The philosopher's name came as no surprise to me. Long before I arrived at the references to him, it was clear to me that Teju Cole's project is a phenomenological one. It is a study of a person's embodied consciousness in relation to the visible world. Merleau-Ponty referred to phenomenology as a "will to seize the meaning of the world . . . as that meaning comes into being." I would modify this statement with an *s*, to the meanings of the world, plural because they proliferate, grow, and multiply. It is further true that these meanings are not immediately evident. Sometimes they elude us. Sometimes our expectations make us blind. And sometimes a period of blindness opens us to visions we have never seen before.

Siri Hustvedt is a novelist and scholar who lives in Brooklyn, New York. She has a Ph.D. from Columbia University in English literature and is a lecturer in psychiatry at Weill Cornell Medical College. She has written and lectured about art and artists for many years.

BLIND
SPOT

TIVOLI

Spring, even in America, is Japanese. It is not only the leaves that grow. Shadows grow also. Everything grows, both what receives the light, and what is cast by it. There is more in the world, all of it proliferating like neural patterns. Almost all of it: it is also the most melancholy season, for, as Alkman says, there is nothing to eat. Resurrection is far too close to death, and the moment when the sleep begins to leave your eyes is the most fragile, the most porous, for at times in spring, even the emotional granaries are depleted.

I remember the lines from *Sans Soleil:* "Newspapers have been filled recently with the story of a man from Nagoya. The woman he loved died last year and he drowned himself in work—Japanese style—like a madman. It seems he even made an important discovery in electronics. And then in the month of May he killed himself. They say he could not stand hearing the word 'Spring.'"

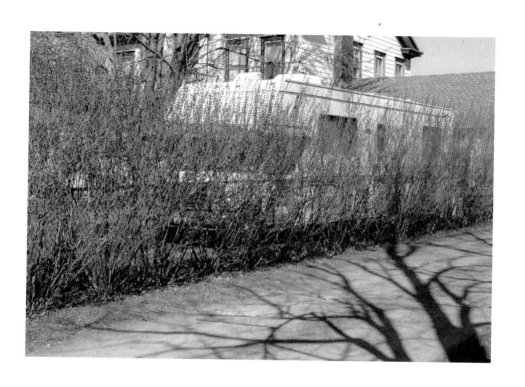

LAGOS

One sense of sleep is the disappearance of the eyes. The head turns inward, toward darkness. Another is an entry into a state of being carried. Outside a church in Lagos, a man sleeps. The body transitions from carrying itself across the earth into being carried by it, into giving itself up to that. The body of Christ is on the now-lowered cross. A white cloth is draped around him. He is not dead, only sleeping (a sleep of two nights and one long day). Around him at the moment of descent are John the Beloved, Joseph of Arimathea, Nicodemus, Mary Magdalene. Closest to him is his mother, in white. John holds out a larger white cloth with which to receive his body. The earth carries the cross. The cross carries the body. The body on the cross carries the world: in a state of sleep, one common dream is that of superhuman strength. It is said (in the Orthodox tradition) that the True Cross is made of cedar, pine, and cypress.

It is said (by Calvin) that were all the fragments of the True Cross held in all the reliquaries of all the cathedrals of Europe to be assembled, an entire ship would be filled with the gathered wood. In sleep, one form of vision is foreclosed, and another becomes available. Outside an Anglican church in Lagos, the sleeping Christ dreams of sustenance and levitation.

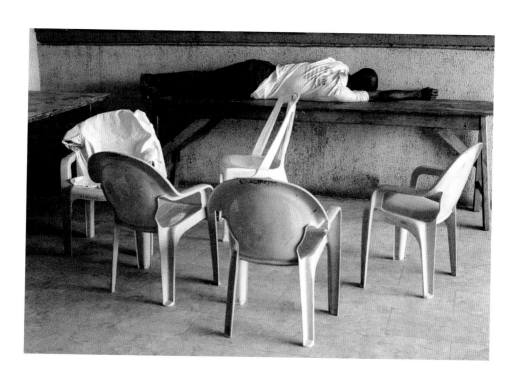

BTOURATIJ

The texture of memory and the texture of dreams are curiously similar: an intense combination of a freedom verging on randomness and a specificity that feels oneiric.

Most narratives of dreams simply don't work, on a technical level, while most dreams do narratively "work" as dreams. You don't have a dream and think, "That was not a dream." But often when you read about a dream, or see a depiction of one, you feel like you're reading about or seeing something that isn't a dream.

NUREMBERG

In the spring of 1507, Albrecht Dürer returned from his second trip to Italy. He had seen Leonardo's oil sketches, and been impressed by their use of drapery to suggest form, movement, wind, and light. A folded drapery is cloth thinking about itself. Under pressure from itself or the influence of external agents, a material adopts a topographical surface. A material, around the axis of itself, faces some part of itself, and confounds its inside and outside.

A drapery study of Dürer's from 1508 shows the influence of a sketch of Leonardo's from about two decades earlier. Folding: "falten": to bring something together, and also to iterate that bringing together: a joining and a repetition. In the crumples, pleats, gathers, creases, falls, twists, and billows of cloth is a regular irregularity that is like the surface of water, like channels of air, like God made visible. The human is the divine enfolded in skin. (There is a curious comment about folds in John's account of the Resurrection: a folded cloth that remained folded even as events unfolded: "Then Simon Peter came, following him, and went into the tomb. He saw the linen wrappings lying there, and the cloth that had been on Jesus' head, not lying with the linen wrappings but rolled up in a place by itself.") In Nuremberg, almost within sight of Dürer's house, I saw, about eight minutes after they began their stellar journey, some several rays of the sun describing the folds on the curtains of my hotel room.

AUCKLAND

Tane and his siblings conspire to push apart their mother, Papatuanuku, the earth, and father, Ranginui, the sky. In the space forced between the two is the light of the world. The light falls and flows between two eyelids.

MUOTTAS MURAGL

They used to burn women here. In these peaceful-looking cantons, women accused of consorting with the Devil were executed in the most sadistic ways imaginable, for God's greater glory. Now the landscape is long settled, like a reputation. The eye scans and organizes the folded mountains. All is at peace. Nevertheless, in one enciphering corner of my mind I believe still that every line in every poem is the orphaned caption of a lost photograph. By a related logic, each photograph sits in the antechamber of speech. Undissolved fragments of the past can be seen through the skin of the photograph. The tectonic plates are still busy in their rockwork, and there is a faint memory of burning ash. The difference between peace and mayhem is velocity.

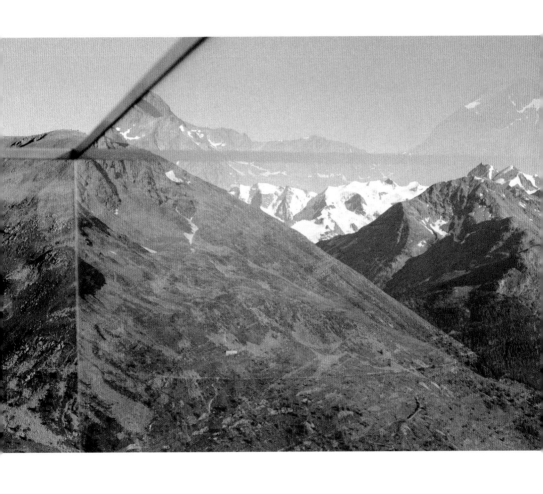

PIZ CORVATSCH

One of the smallest things in this picture—the reddish mound at the southwest corner of the red mesh—is in reality one of the largest. The picture was made at three thousand feet on Piz Corvatsch in the Engadin, and that wine-dark smudge is one of the great peaks of the Bernina Alps. From this point of view, it is about the same size in terms of area as the last small parcel of summer snow on the scree. Both are far smaller than the open shadows cast on the bottom left by unseen railings. Corvatsch was Nietzsche's favorite mountain, and maybe a line from *Ecce Homo* could caption this picture: "Philosophy means living voluntarily among ice and high mountains."

But maybe not. Something less strident is needed for an inventory picture like this one, in which no square centimeter is allowed to lord it over any other one, just as we learn in school that a kilo of iron miraculously always weighs the same as a kilo of feathers. Instead of philosophy, this is a picture of fact: siding, poles, mesh, sky, mountain, gravel, railing, and shadow, as well as color, angle, horizon, and loss of balance.

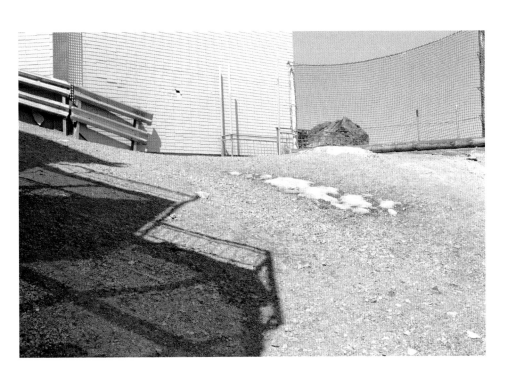

CAPRI

Later on, I thought of the catalogue of ships in the *Iliad*. "I could not tell over the multitude of them nor name them, / not if I had ten tongues and ten mouths, not if I had / a voice never to be broken and a heart of bronze within me, / not unless the Muses of Olympia, daughters / of Zeus of the aegis, remembered all those who came beneath Ilion." But that was literary, that came later. On the day itself, on the evening of the morning in which I opened up the window of my room to see the apparition of a shining fleet on the Mediterranean, what I thought of was what Edna O'Brien said to those of us in the audience: "We know about these beautiful waters that have death in them."

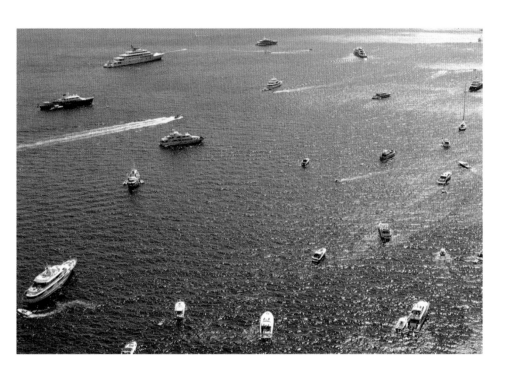

McMINNVILLE

In February 1930, a man and a woman were involved in a car accident, the man died instantly. The woman, his wife, not long after. She'd been pregnant. Their son, raised in an orphanage, became an industrialist, founded an aviation company, and died at age eighty-four in 2014.

In March 1995, a former fighter pilot died in a car accident before his thirtieth birthday. His grieving father, who had founded an aviation company and was to die many years later at the age of eighty-four, in 2014, was said by locals to have been CIA, a charge he never confirmed or denied, saying only that it was better than being KGB.

TRIPOLI

The date to remember is 1654. He paints *The Goldfinch* that year. The color harmonies are cool, the wall is as full of subtle character as a face. His life is like a brief and beautiful bridge. He studies with Rembrandt in Amsterdam. He teaches Vermeer in Delft.

I am walking in the narrow alley between the castle of the Crusaders and the busy souk. There are children wild in the alley. There is a bird on the wall. It is him, Carel Fabritius. The bird suggests it (though this bird is a bulbul) but it is the wall that confirms it. Suddenly the gunpowder depot explodes. Fabritius is killed, and most of his paintings are lost to history. But not all is lost. The bridge has been built and it has been crossed, the bridge from shadow into light. He is not yet thirty-three years old.

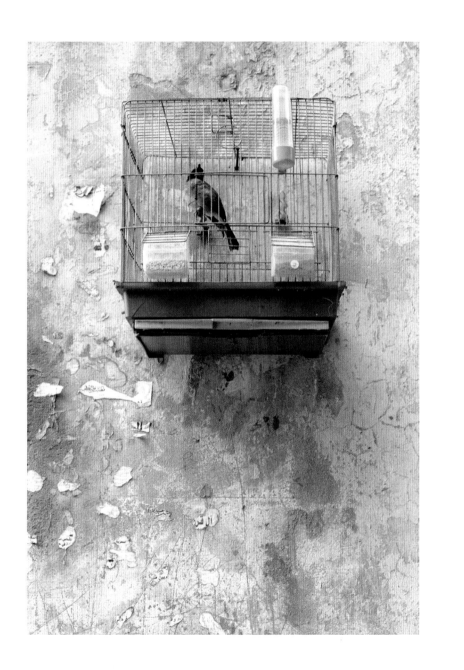

BRAZZAVILLE

There is that which is carried, like a cross. There is that which drapes over, like a funeral sheath. Everywhere, I begin to see as I am carried along by my eyes, are these two energies, which, with water as the third, together begin to constitute an interpretive program: the solid (like wood, iron, or stone), the solid-fluid (clothlike), and the fluid (water). On the banks of the Congo River one afternoon, a boy plays on a railing. He wears a white shirt and black gloves. Ahead of him is the cross on which he is supported, reinterpreted as red elements of iron and painted concrete. On the boy's body is the infant Christ's towel, the condemned Christ's loincloth, the Sudarium of Saint Veronica, the linen shroud of burial: white cloth on a body, the solid-fluid that mediates between the cross and the river. Behind him, the river rushes. Is he a type of Christ, or is he an angel (that glove is as intense and uncanny as a pair of wings), or is he Saint Christopher, the Christ bearer at the river's lip? But all three are carriers, and types of one another too. Like them, the boy moves between metaphors. Suddenly, he lowers his head, his eyes disappear.

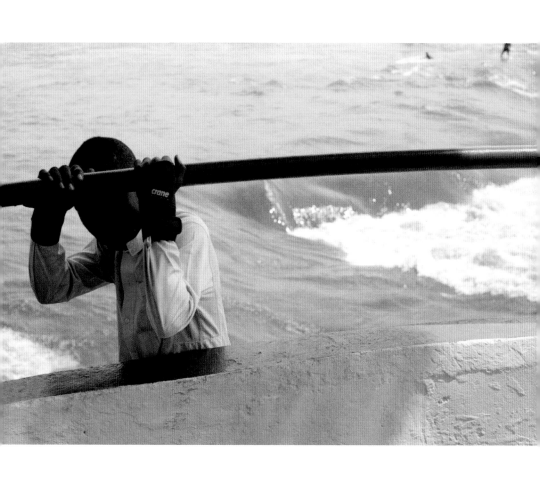

POUGHKEEPSIE

A fluency in the dialect of geography, miniatures, and paper, an inclination for creating a gently fabular atmosphere, a commitment to what seems to be plain description, a return one way or the other to the empty dreamlike classroom, and a testing of the shimmering boundary between the map and the territory are some of the things Elizabeth Bishop, Luigi Ghirri, and Italo Calvino have in common. The empty chalkboard bears the ghostly trace of everything ever written on it. Each soul has its genetics.

Pull screen down all the way. HESITATE... then allow screen to retract VERY SLOWLY until it locks in place.

Sarmatae

MARE

MILAN

It holds its violence in reserve. It is symmetrical, as are most verte-brates. It is in fact bipedal, like the animal that stands up, the animal that can mourn strangers. This suggestiveness is the key to surrealism. Sud-denly coming up for air, a whale breaking the sea's surface, the surreal object is beyond or over (sur) a reality it might have been expected to stay below. The scissors is a mask without a face.

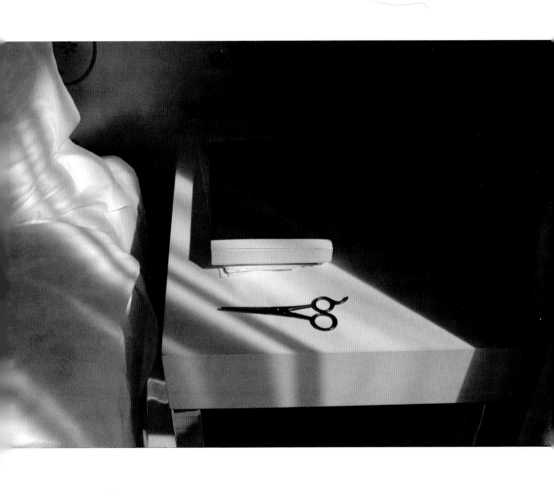

BERLIN

He is masked by the shine. The mask spreads outward. Outside the gilt frame, on the periphery, are various things imperfectly seen: too dark, too small, cut off, blurred. I took this photograph at the moment my friend came down into the lobby. It was the night we were to see the Brahms violin concerto at the Philharmonic. From time to time, people leaned back and closed their eyes, so that Brahms would seep into their bloodstream.

BTOURATIJ

We were a few miles from Tripoli, which is dry, so we stopped by a café to get our last glass of wine. The woman who owned the place was from Iraq, and the café was decorated with postcards and images of Iraq's ancient history. She brought us white wine. The sun was so bright outside that the road was almost white.

Babel, famous for its tower, became Babylon, in Iraq. On the wall in a café in North Lebanon, Bruegel speaks for Iraq. Bruegel: he painted many things that cannot be painted.

ZÜRICH

I walk around the city not knowing if I am a giant in a miniature land-scape or a midget in monumental surroundings. The bright sun obliter-ates scale. The city is modular: office plans look like city maps, and the façades of buildings resemble street plans. In this fractal city, each frag-ment is the city in microcosm. Glimmering things—narcotics, stimulants—are stacked and hover just out of reach behind grille and glass. The city is a druggy rush of machine: rectilinear, vertical, tantalizing, and masked. You zoom in and in, and still remain recognizably in the city.

Imagine the city destroyed, and out of one surviving miniature, out of the DNA, say, of a shop front, the city had to be reconstructed—as in *Jurassic Park*. This is one possible city, the central city. The other is the city of peripheries, which with looser structure also contains the code of the city. Both cities are ever-present in the continuous city.

BERLIN

Each brick contains within its form something crushed.

I am on the board of an arts organization. We meet in the organization's postwar building. The design is beautiful, the rooms large and airy, the whole structure surrounded by a park. For three days we talk about the future. We drink coffee, look at charts, and exchange ideas. I enjoy the intelligence of the curators and my fellow board members. At the end of the third day, the director draws our attention to the past.

On the map of the building we are in, a second map is superimposed: the building that had been there before, before its destruction in the war. (I remember the pain when the doctor cauterized the holes in the retina of my left eye with a laser. An intense pain, not bitter like a knife but sour like darkness.) That first building is constructed in 1872. The banker Hans H. purchases it on an unrecorded date. Charlotte H. inherits the building in 1918, when her husband dies. From 1928 onward, two upper floors are converted into a clinic, for which one Kurt P. is hired as bookkeeper.

After 1933, the Jewish owner is no longer allowed to operate the clinic. In 1937, Kurt P. purchases the clinic, for a price well below its market value. Charlotte H. has three sons, all of whom flee Germany. Charlotte H. remains, steadily becoming poorer, and in March 1943, she is deported from Berlin to Auschwitz-Birkenau. Her fate there is (un)known.

BERLIN

Like speech, which leaves no mark in the air, the arrangement of our bodies leaves no mark in space. A moment later, the man by the trees has moved on. He has not noticed his echo behind him, and the man who echoes him has not noticed him or, even if he has, has certainly not noticed himself noticing him. There are thousands of such echoes and agreements every minute. Almost all go unseen, and almost none are recorded, unless photography intervenes. Berlin is a city of ever-proliferating and overlapping peripheries. But even here there is a code, though it is a code made of wounds.

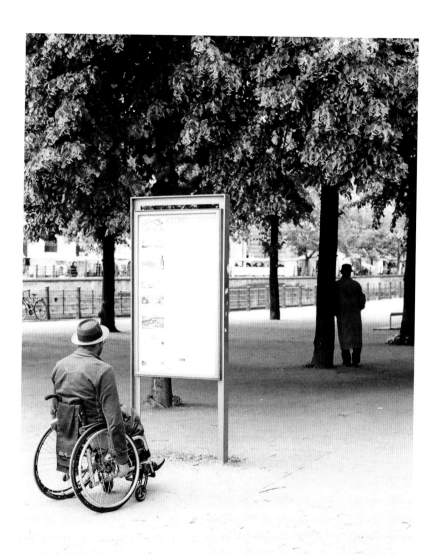

SASABE

Far from the city. Through narrow darkness, through scrub forests and rocky cliffs, our Elder Brother brought us across, his name was I'itoi. On our setting out from the other side, he turned us into ants. He brought us through narrow darkness and out at Baboquivari Peak into this land. Here we became human again, and our Elder Brother rested in a cave on Baboquivari, and there he rests till this day, helping us. The land is a maze. You have to be guided through, right from the beginning you had to be guided. The first story in the world is about safe passage. An iron fence spirals into the distance, enforcing on the land a separation in the mind. In the grass near the inspection post at Sasabe, on the Mexican side, someone has planted two white crosses. The large one lists at a sixty-degree angle. On the smaller one, you can see the word "mujeres." The code is made of wounds.

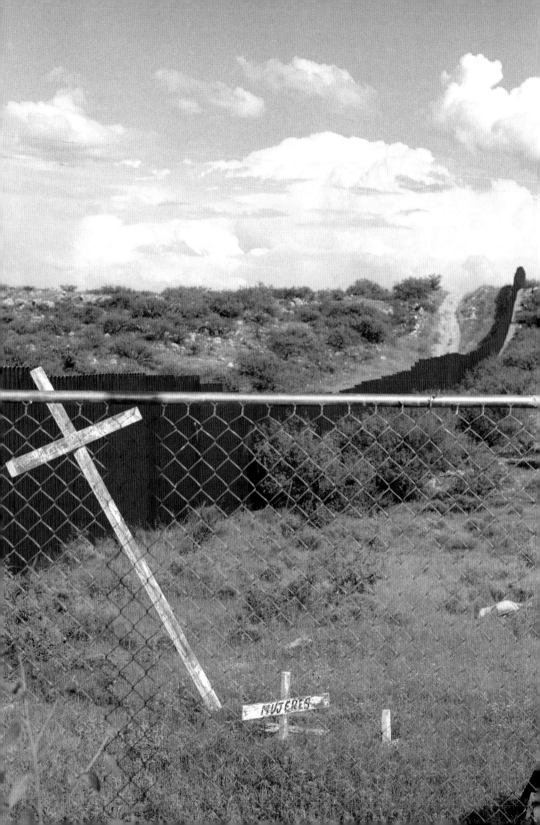

LAGOS

On the other side of the church from where the man sleeps on a table are two graves by a wall. They are tiled, as graves in Nigeria sometimes are, one of them in black, the other in blue bath tiles. I have seen both baths and graves done up in this style. As though to underscore the balneal theme, among the detritus between the two graves is a disused bathtub and an orange plastic bucket of the kind often found in Nigerian bathrooms.

At the end of Book 10 of the *Iliad*, Odysseus and Diomedes spend a long night killing Thracians. "And the men themselves waded into the sea and washed off / the dense sweat from shin and shoulder and thigh. Afterwards / when the surf of the sea had rinsed the dense-running sweat away / from all their skin, and the inward heart had been cooled to refreshment, / they stepped into the bathtubs smooth-polished, and bathed there."

The overlap between the grave, the bath, the bed: strategic escapes from the burden of verticality. And, lying down, without even thinking about it, you close your eyes. "Bathtubs smooth-polished," Homer writes. Later on, Andromache draws a hot bath for her husband, Hektor, who (she doesn't know this) is already dead. Hektor, who is already dead and isn't coming home to take a bath.

BROOKLYN

One of the common uses of the word "shadow" was as a synonym for "photograph." This was the sense in which Sojourner Truth used it when she wrote, on the 1864 photographic postcard bearing her image, "I Sell the Shadow to Support the Substance."

Sojourner Truth's photograph was made in Detroit, and she sold copies of it to raise funds for antislavery causes. Looking at a photo I made in Brooklyn, I'm reminded that "Detroit" used to be a synonym for cars. Here is a shadow above, clearly labeled, and enmeshed below it, the substance (which, less shadowed, looks slightly less real).

For a long time, I avoided having cars in my photographs. Now I know they are our shadow on the earth, our prosthesis. From time to time, I wake up in the middle of the night, heart pounding, and remember what another poet wrote: "but often the shadow seems more real than the body. / The samurai looks insignificant / beside his armor of black dragon scales."

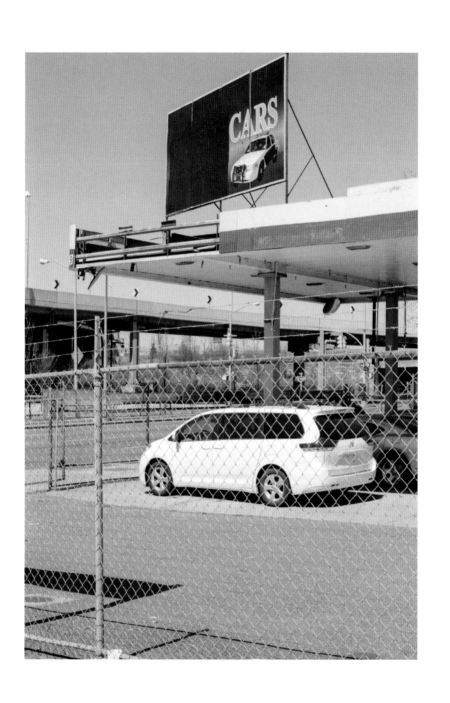

NUREMBERG

They are ever with us, the cars. We live and die with them, they give us joy. The three photographs before this one feature or allude to crosses. In minds shaped by the influence of Christendom, the means of Christ's death is ever-present, ever-visible.

Founded by the Nazis in 1937 as the Gesellschaft zur Vorbereitung des Deutschen Volkswagens mbH, the company was later renamed Volkswagenwerk, or "the People's Car Company." In commissioning the VW Beetle, Hitler said: "It is for the broad masses that this car has been built. Its purpose is to answer their transportation needs, and it is intended to give them joy." The crucifix is literal in this photograph I made outside the medieval Church of Saint Sebaldus, on Albrecht-Dürer-Platz, in Nuremberg. Christ on the cross, in the conventionalized agonies of crucifixion, is attended by John, Mary, and a pair of medieval saints.

Due to the emissions scandal, the value of the company's stock has fallen by 11 percent. Saint Sebaldus was bombed in 1945, reduced almost to rubble. It was meticulously reconstructed in 1957.

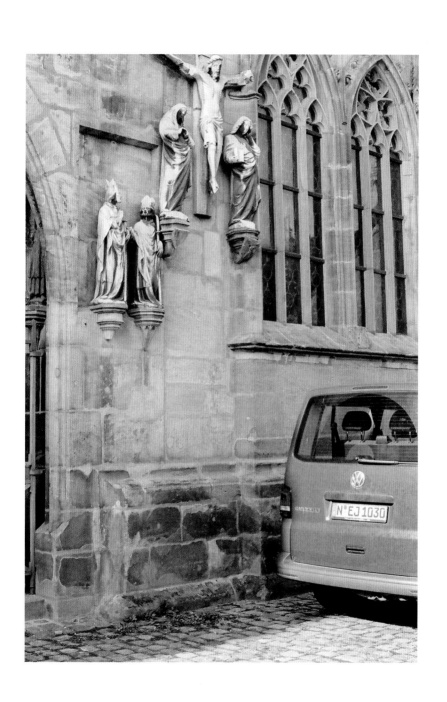

UBUD

We are advised not to say: "1965." We are advised not to say: "The events of 1965." We are advised not to say: "In 1965, following a failed coup, the Indonesian Army stoked communal hatreds leading to a massive anticommunist purge. The victims and the executioners were ordinary Indonesians. The American government provided lists of communists to Indonesian death squads. The CIA, in a secret report, stated that the massacres 'rank as one of the worst mass murders in the twentieth century, along with the Soviet purges of the 1930s, the Nazi mass murders during the Second World War, and the Maoist bloodbath of the early 1950s.' The number of dead comes to more than 500,000. Here in Bali, the populations of several villages were halved in the last months of 1965. All the Chinese shops in Denpasar, the largest Balinese town, were destroyed. Their owners were killed. In the space of a single year, about 80,000 Balinese were killed. There has been no accounting of these horrors, the perpetrators move about freely, the survivors are uncompensated." We are advised, as visitors to Bali, not to bring the events of 1965 up in public discussion.

LAGOS

When I was a little boy, I suppose around the time I was seven or eight, and therefore it must have been in the year 1982 or '83, I was in my mother's office one afternoon after school, doing my homework. I kept writing things and crossing them out, writing things and crossing them out. I was working with a ballpoint pen and wasting sheet after sheet. Finally, Mom, exasperated, gave me a very strict task: I must write to the end of the page, cleanly, nothing crossed out. She's my mother, so I followed the absurd directive, like an orchestra compelled to play to the end even though they are mucking up lots of notes. All I remember now is the brilliantly clean text I was able to produce that afternoon, and my sense of wonder that it was indeed I who had done all that elegant-looking writing.

I am fascinated by the vast spaces that surround Twombly's scribbles. Like having two rooms in a New York City apartment that you use for nothing, while all your possessions are crammed into the third; an indefensible spatial luxury.

ZÜRICH

I associate Switzerland with ease and calm. With some war, but only in the long-ago mercenary past. Switzerland is neutral now, serene, safe. But I begin to think of those new Swiss weapons, and all the places and bodies that had been blown apart by the hundreds of millions of dollars of annual Swiss arms sales. Bombs, torpedoes, rockets: to the United Arab Emirates, to Saudi Arabia, to Botswana. The blasted buildings of Beirut. Sig Sauer rifles and handguns find their way to the American street. I associate Switzerland with calm and ease. What then is not visible? The death merchants busy at their precision work. And I begin to worry that my search for information about these handguns and weapons of war would flag my activity as suspicious to the all-seeing eye of the government. What then is visible?

LUGANO

She said to me: Europe is getting worse. I still don't understand why you want to move to Switzerland.

I said to her: I don't want to move to Switzerland. Quite the contrary. I like to visit Switzerland. When I'm not there, I long for it, but what I long for is the feeling of being an outsider there and, soon after, the feeling of leaving again so I can continue to long for it.

GADSDEN

William Moore died in Etowah County in 1963, shot to his death on a highway near Gadsden by God knows who, but we can guess. William Moore was white. A postman from Baltimore, he was walking through Alabama alone to deliver a letter against segregation. Sandwich board on him said "Equal Rights for All (Mississippi or Bust)." William Moore was thirty-six years old that year and schizophrenic but not paranoid. He would walk from Chattanooga, Tennessee, to Jackson, Mississippi, and discuss equality with the governor of Mississippi white man to white man. William Moore believed in reason.

The coroner, Noble Yocum, was called to come get his body. Protests by blacks in Gadsden followed. In Birmingham, it was attack dogs and fire hoses, but in Gadsden, Colonel Al Lingo of the state patrol introduced cattle prods. Those burn. Black skin burned then, in Gadsden, that summer of '63, and the smell of burning flesh was in the air. In 1964, the Civil Rights Act was passed. There's Klan in those woods still.

PALERMO

In the Piazza Marina in Palermo is a massive ficus tree with elaborate aerial roots. In the shade of this tree, there is a small bronze plaque that bears the name of Joseph Petrosino. Petrosino, of the NYPD, was associated with a number of high-profile cases, including catching the blackmailers of Enrico Caruso.

Sweeter than any music is the sound of mild human activity in a quiet corner of a city in summer.

In 1909, Petrosino came to Sicily to investigate some "men of honor" believed to be members of the Mafia and the Black Hand. He himself had been born in the Kingdom of the Two Sicilies in 1860. As an immigrant to America, he believed organized crime brought shame to Italian Americans. On March 12, shortly after his arrival in Palermo, he received a phone call asking him to meet an informant at the Piazza Marina.

The temperature was close to ninety degrees. I wandered without a map. I watched some old-timers playing a board game. A pair of boys wheeled by on their bikes. Two traffic officers stopped two surly men in a small car on Via Vittorio Emanuele, which lies between the late fifteenth-century church of Santa Maria della Catena and the piazza. A long conversation ensued. The men in the car got surlier. I climbed up the steps of the church, and from the portico made my photograph.

While waiting for the informant in broad daylight, Petrosino was shot to death by a number of men. The plaque in the shade of the ficus reads: "Joe Petrosino / Lieutenant della Polizia di New York / La città ricorda ed onora il sacrificio dell'investigatore Italo-Americano / Palermo." His killers have not been definitively identified to this day.

OMAHA

Camera. The small, dark room: "camera." Photography is shadow work, controlled exposure. There is therefore an irony (if not quite a paradox) in showing photographs: extending into the public what is birthed in secret. I think now of the Gospel of Luke: "Whatever you have said in the dark will be heard in the light, and what you have whispered behind closed doors will be proclaimed from the housetops." Each photo, when seen, when brought out of the small, dark room, is a fulfillment of prophecy.

WANNSEE

I wrote to her, "The house is nice, but Kleist shot himself about a hundred yards from here." She wrote back, "Within a hundred yards of anywhere, someone's shot himself."

MUOTTAS MURAGL

In the spring, I twice watched Olivier Assayas's *Clouds of Sils Maria*, in which a woman (Maria Enders, as played by Juliette Binoche) said: "I had a dream. We were already rehearsing, and past and present were blending together." And I really did not know in that moment if I was dreaming, or remembering a dream, or watching a film, or remembering the first time I watched the film and heard Juliette Binoche say those words. In the summer, I went to the Engadin and Sils Maria for the first time, half in pursuit of this dream. In the fall, looking at the photograph I had made on the mountain and writing about that visit, I could not say for sure whether on that cloudless evening on Muottas Muragl, over-looking the Engadin all the way to Sils Maria, I had remembered the dream by Maria Enders, or whether I had only later dreamed that I had remembered it there.

COPENHAGEN

"They came to the other side of the sea, to the country of the Gerasenes. And when he had stepped out of the boat, immediately a man out of the tombs with an unclean spirit met him. . . . Then Jesus asked him, 'What is your name?' He replied, 'My name is Legion; for we are many.' "

At the Ny Carlsberg Glyptothek in Copenhagen is a photograph of a Catholic procession in rural Southern Italy. Next to it is a high marble relief of a Roman ritual procession from around the time of the Ara Pacis. It depicts a number of women in profile. Between the relief sculpture and the photograph is the museum's russet wall, split so that which section is in front and which is behind is hard to read. The relief sculpture looks in fact like a photograph of a sculpture, and is difficult to resolve into its three-dimensional form. The women from 1 B.C.E. are on the verge of crossing the red sea and joining their distant Italian daughters and sons.

LUCERNE

The work of Gabriele Basilico (1944–2013), new to me. Near the beginning of the exhibition, a shaft of sunlight moves across the wall. A photograph of some young people, from the early part of his career. I cross the darkness and join them.

MANTUA

If the polygon of sun in the previous picture is light scooped out of dark-
ness, and the russet wall in the picture before that is a river of color, the
ribbon here is expert ink calligraphically snicked into a pale surface.
From the flatness emerges the eventual meaning: something touching
on something, a delicate form holding, for sustenance, a more solid
form. The gesture is doubled: there are two ribbons. The gesture is
doubled twice: there are two ribbons not only touching but actually loop-
ing around the column: they both touch on the column twice, and the
entasis on the column itself echoes the soft give of the navy blue rib-
bons. The gesture is doubled three times: in a fresco upstairs (for this is
the Palazzo Ducale in Mantua), a little girl extends her arm to gently hold
on to the fingers of her brother who, with his other hand, holds their
father's hand: a length, a loop, a line.

ZÜRICH

A length, a loop, a line. Faraway wave seen from the deck
of the ship. I think the Annunciation must have happened on
a day like this one. Stillness. In the interior, she reads with
lowered eyes, unaware of what comes next. A presence
made of absence, the crossbar, the cloth, the wound in his
side.

SEMINYAK

The broken roof in the left panel represents the old covenant, which will be supplanted by the birth of Christ. Saint Luke, the image maker, is present to create a portrait of the Virgin. Above him is Saint Joseph's workshop, complete with table and tools, where he creates the mousetrap that will trap the Devil. On the right panel is a pale landscape receding into the distance, foreshadowing the desolation of Golgotha. In the central panel of the triptych, we see the Virgin Mary in blue, arms folded across her chest. The footstools represent her future dominion as the Queen of Heaven. The Angel Gabriel's wings are emerald green. The light, arriving from the top left, is clear, full, and of unusual lucidity. The predella is unfinished.

LAGOS

A few days after Christmas, musical instruments sleep in a primary school hall in Lagos. Gone is the noise of the schoolchildren. The year is ending. The silence roars like outer space.

ZÜRICH

I sat there for hours and watched the sun slip across the landscape. Anything can happen. The point is to shatter serenity; the absurdity of contrast between before and after is the very point. It could be in a shopping mall, a café, a public square. It could be in a restaurant or at a concert, in the places where people gather and are happy. I am haunted especially by the innocuous phrase I saw in a news article—"in hotels popular with Westerners"—for these are the most frequent targets, and these are the places where I spend my days and do my work. (I write these words in yet another hotel in yet another city.) But in the places I don't live, in other cities, in remote borderlands, on farms, what happens also happens there, and it happens just as suddenly, just as grievously; but less visibly. I remember this: against the impassioned claims of the nascent Black Power movement in 1966, Martin Luther King, Jr., driven to exasperation, said to a Mississippi gathering: "I'm sick and tired of violence. I'm tired of the war in Vietnam. I'm tired of war and conflict in the world. I'm tired of shooting. I'm tired of hatred. I'm tired of selfishness. I'm tired of evil. I'm not going to use violence no matter who says it!" I sat there for hours, in one of those hotels popular with Westerners, and watched what Roethke called "the deepening shade."

RHINECLIFF

He was frail when I last saw him read. This was in 2010, some years after the stroke. I don't remember if he had trouble walking then, but we thought of mobility because he read from "Miracle":

Not the one who takes up his bed and walks
But the ones who have known him all along
And carry him in—

There was always bipedal grace in his poetry, the this helping the that, a forward motion. Years later his loss left me tottering.

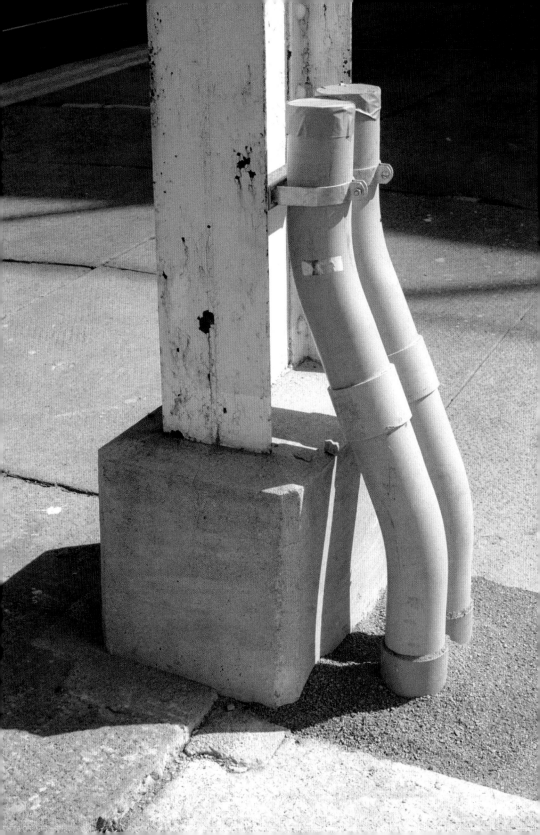

ZÜRICH

That morning in the spring of 2011 that I woke up blind in one eye, the morning the mydriatric drops blurred the other eye, there was nothing technically wrong with either of my legs. And yet, I had trouble walking. Verticality and balance both entered a contingency. I tilted, staggered. Carefully going down a bright street in an unfamiliar town as though I had only just relearned how to place one leg in front of the other. Frailty of one of the senses might increase the liability in another of them, just as (more commonly observed) the opposite could be true: the loss of one sense leads to the hypertrophy of another. Blindness momentarily made my ears more acute, but I need to see to walk.

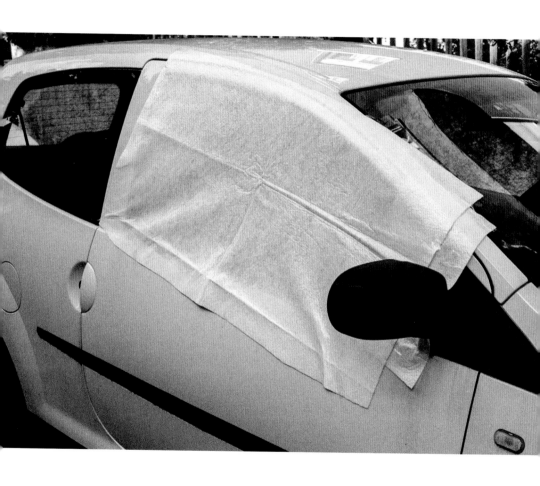

BOMBAY

"In a dark time, the eye begins to see." Quite by chance, while I was taking a photograph of the one-eyed car in Zürich—late afternoon, and the sun was going from the streets—I heard a friend's voice behind me. "Was machst du denn da?" She laughed. I turned around and saw in her eyes a gale force grief, for her mother had only just died the previous week.

BEIRUT

I peeked into a house in Mar Mikhael for a moment. A black woman was sweeping a stone floor. At the threshold was an image of the Holy Virgin.

I saw many black women in Beirut. Those of them in domestic employment, when out on the street, carrying their employers' children or not, walk behind. Their servitude, their inequality, is made visible. Many of these women are Ethiopian (Ethiopian men are few in Beirut, though male Sudanese laborers are plentiful). The Ethiopian women are hired because they are Christian and English-speaking, desirable qualities in nannies. On Saturday nights, they have semisecret nightclubs away from the glitzy areas. In these clubs (I visited two) they socialize with one another, and with Lebanese, Syrian, and Sudanese men, dancing to Ethiopian, Arabic, and Nigerian music. They are dressed to the nines, their hair is done, and they wear high heels. They look nothing like they do when they are with their employers. And on Sundays, on their day off, you can see them on the street in groups, in white, flowing through the street, their spirits shining from having attended church, the condition of servitude briefly lifted.

Many of these women are in Lebanon illegally. When they wish to return home, they have to raise enough money to cover the costs of their deportation—transportation as well as fines. When the money is raised, they turn themselves in to the nearest police officer, and, after a brief spell in jail, they are deported.

Just south of Bachoura is Basta Tahta, where the roads are worse, and there are more posters on the walls, of imams, politicians, and martyrs. Basta Tahta is mixed, but support for Hezbollah is palpable. S guides me through a tangle of streets to a building with a wide-open passage on the ground floor. The passageway stinks, but the source of the smell is

not immediately apparent. A couple of doors down in the dark passage, we find the shop belonging to M, a Sudanese barber.

The shop doesn't smell bad, and it has three chairs. He is working alone. There are customers from South Asia, Bangladeshi mostly, and there's an hour's wait. I go walking in the neighborhood, a day of bright sun, which picks out in a rather surreal way the strong colors of things in the street. I see a pair of plastic watering cans that, unexpectedly spotlit by the sun, look like blue flamingos.

I return to M's for my haircut. The power supply is out. He uses mechanical clippers, cutting close to the skull. He's kind and welcoming, and chats as he cuts my hair, but he is not a good barber. I have bumps in my neck days later, from where he pressed too hard.

I ask to use the bathroom just before I leave. He leads me into the stinking passageway, and opens a door next to the one-room barbershop. It's a tiny studio apartment, his own I presume. A bed with tangled bedding, a bathroom the size of a closet, one towel, one toothbrush, one bucket, a pit toilet, the bare minimum. The room and the shop constitute M's kingdom, among people who know nothing of him. Out in the streets, I don't see other black people. If things go wrong, who will defend him? I feel he is entirely unprotected, a stranger in a strange land.

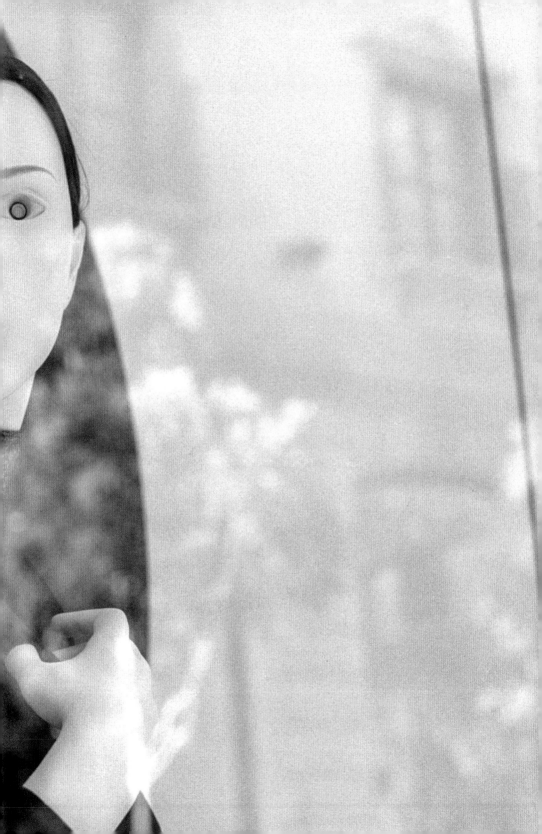

BERLIN

The human being, born naked, is plunged into private darkness under a shroud. The fashion in Guantanamo has suited ISIS well for inspiration. The jumpsuit, oversized, is rolled up at the ankles. The hood, like an eyelid, draws attention not only to what is hidden, but to what would look right back at us if it could.

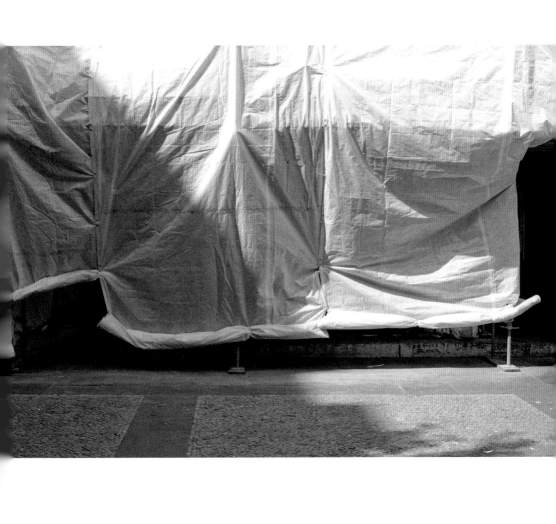

WANNSEE

There was a construction project for a few weeks outside my room.—"'Reach out your hand and put it in my side. Do not doubt but believe.' Thomas answered him, 'My Lord and my God!' Jesus said to him, 'Have you believed because you have seen me? Blessed are those who have not seen and yet have come to believe.'"—Six miles from Wannsee is Sanssouci, in Potsdam. When I made this photograph in Wannsee, I did not know that Caravaggio's *The Incredulity of Saint Thomas* was in Sanssouci. Has there been a more intense or more erotic demonstration of the sense of touch than in Caravaggio's painting? The split in Thomas's shirt is the same size and shape as the wound in the side of Christ: both are eyes that short-circuit vision. Christ advises Thomas to surrender the sensual faculty in favor of the cognitive. But his hand, guiding Thomas's hand, says something different. Caravaggio, as usual, goes to that dark core where action splits from intention. I was based in Wannsee for the summer, and spent some of my time going to distant places in search of paintings by Caravaggio: to Madrid, Venice, Basel. I missed the Caravaggio right next door.

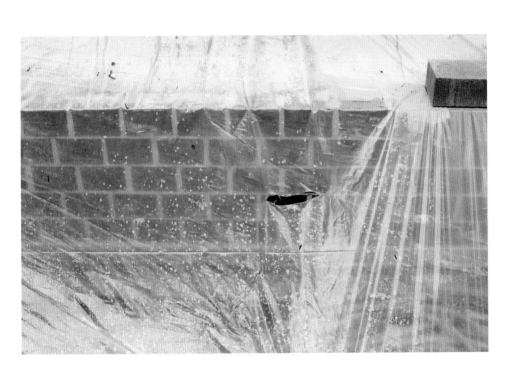

ZÜRICH

The vulnerability, in the sun's light, of an object. James of Milan (late thirteenth to early fourteenth century) expresses in his mystical devotional text *Stimulus Amoris* a desire to copulate with Christ "wound to wound." A century later, Julian of Norwich also recognizes the erotic charge of Christ's woundedness. The pun between "vulnus" (wound) and "vulva" accommodates these sexual readings.

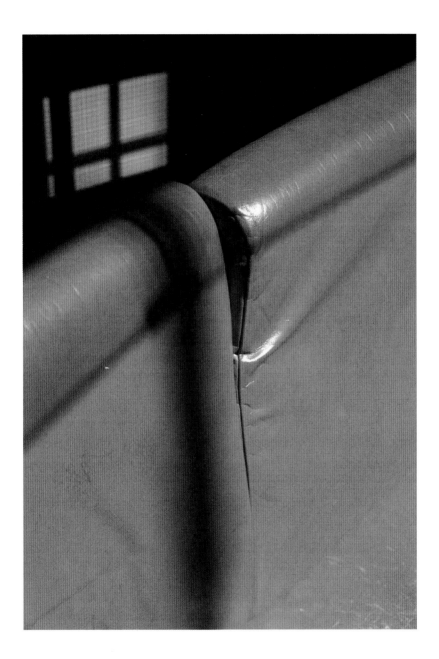

NEW YORK CITY

And in this case it was the real city that seemed to be matching, point for point, my memory of the model, which I had stared at for a long time from a ramp in the museum.

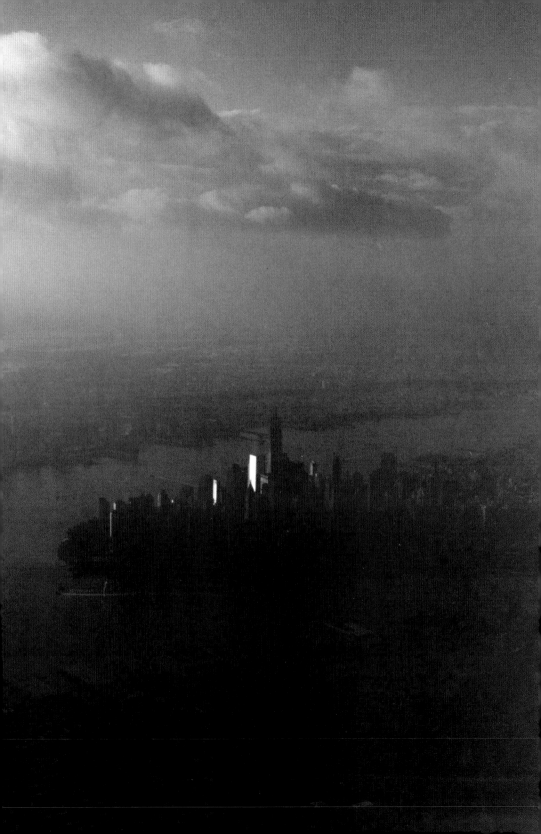

NUREMBERG

In March 1498, the Nuremberg goldsmith and printer Anton Koberger published Ludovicus of Prussia's *Trilogium anime,* for which Koberger's godson Albrecht Dürer provided an illustration. Ludovicus, in his discussion of fantasia, touches on the composite nature of the chimera, that creature of legend whose hind parts were a dragon, the middle parts a goat, and the fore parts a lion. The world of dreams, Avicenna suggests, comes to pass when the rational brain gains unhindered access to the imagination's storeroom of images. Dürer, considering the question of Beauty, wrote: "I often see great art and good things while asleep which do not occur to me awake. However, when I wake up the memory of them is lost." But from time to time, in certain heightened states in certain individuals, the boundary between the chimeras seen in dreams and the discrete forms of waking life begin to blur. In these sudden rifts in the natural order of time, prodigies of vision in the guise of hybrid forms can appear briefly, before the critical faculty intervenes and the world rights itself again. It was a hot day and I had been walking for a long time.

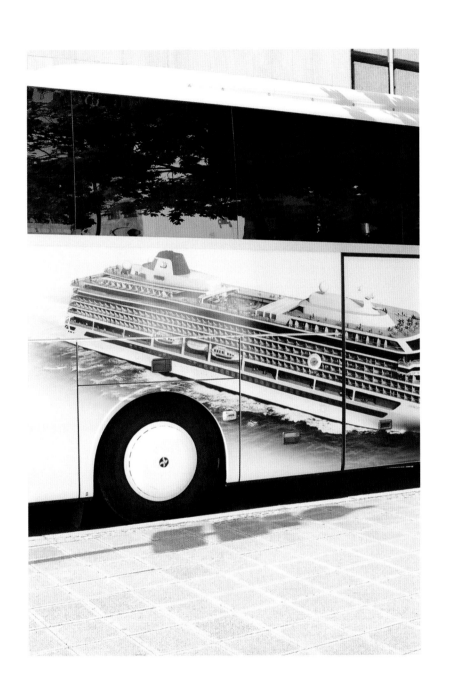

PALM BEACH

Aristotle says the soul never thinks without an image. Giordano Bruno, following, says to think is to speculate with images. A view turns out to be a view of a view, as though reality had been caught unawares, half-naked. "Speculate": for the first time I notice there's a mirror in the word.

MILAN

There came as a suppliant to the god Asklepios a man who was so one-eyed that on the left he had only lids, there was nothing, just emptiness. People in the temple laughed at him for thinking he would see with an eye that was not there. But in a vision that appeared to him as he slept, the god seemed to boil some medicine and, drawing apart the lids, poured it in. When day came the man went out, seeing with both eyes.

—*Inscriptiones Graecae*, IV 2.1.12.1

At Asklepios's temple in Epidaurus, you sleep so that in dreams you may find a cure for your illness, so that you may "see with an eye that was not there." It is the sleeping that cures the illness. The inadvertence of the dream narrative that opens, like a door, what had been sealed shut— your happiness, your ability to walk, your darkened eye—and grants new admission to the world's marvels.

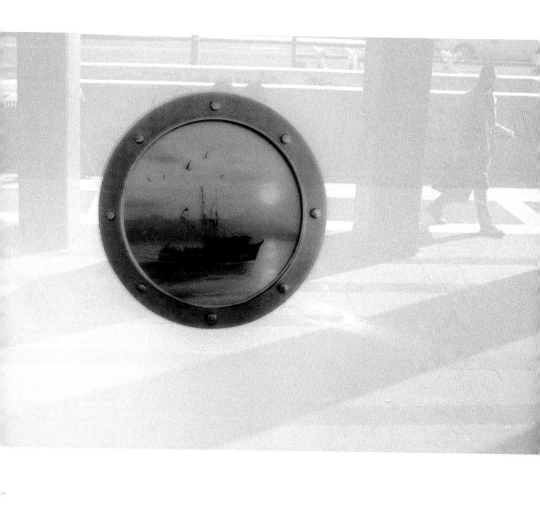

BROOKLYN

Losing myself in the city during those aimless walks, I encounter chime-
ras made of lexical fore parts and material hind parts. A sign saying
"cars" bearing an image of a car above a car. Sometimes the indication
is crossways: the vessel carrying the image of the ship is the image of
the bus. There are signs that say nothing, that reveal, like the poker-
faced skull under all our facial expressions, the bedrock truth of it all.
But almost as interesting as these signs of nothing are those signs that
announce only that they are signs, signs that live as an homage to sign
as sign.

A week later I walked in the area under the Prospect Expressway.
The "sign here" sign was gone, replaced by an ordinary sign selling
something.

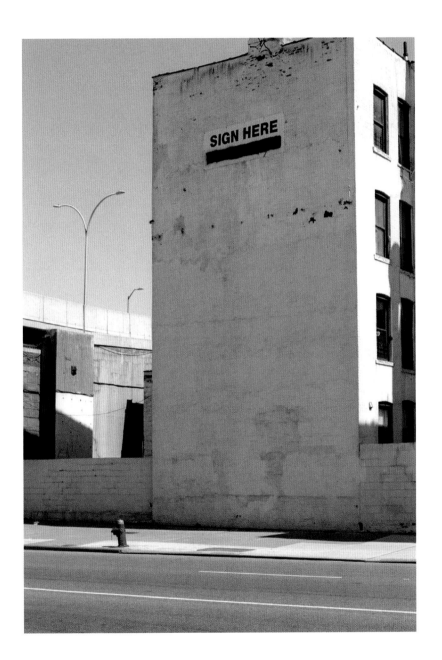

BAALBEK

The first time our ancestors climbed a tall tree, or came in a migrating band to the edge of a cliff, they experienced vertigo. Only hundreds of thousands of years later did we experience jet lag, which is to chronological displacement as vertigo is to spatial displacement. Finally we had figured out how to move across time faster than time moves across us. In epiphany, you are neither here nor there. In jet lag, you're in duple meter, both here and there at the same time.

BERLIN

A corner in the city is a sign of the city. The cityscape is full of hidden signs, and at times moral exigencies compel what was hidden to become visible. If you walk farther down Niederkirchnerstrasse, you will find a strange complex of buildings and unearthed subterranean ruins. These buildings were the headquarters of the Gestapo and the SS, and nearby are other buildings that were used during the campaign of terror and mass murder that sent millions of people to their early deaths. There's a cellar here, preserved, where political prisoners were tortured and killed. The site, now named the Topography of Terror, has been turned into a documentation center for these horrors. Evil ground because of what happened here, holy ground because of the innocents it consumed. All cities are places where traces remain of things that happened—Berlin is a compressed instance of the phenomenon, a synecdoche for organized and disorganized violence, a sign that reads "sign here."

VALS

Something covered. Something waiting. Something under pressure. Something pressing on something else. Something pressed on and having difficulty breathing. An extension of something horizontal and elastic to something vertical and rigid, to which it is attached with a clasp or a hook. Something black. Something green. Something voluminous but light. Something with bars, like a cage. Something swollen and protuberant, like a cock in a pair of jeans. Something seen through a translucency. Something that has been touched by human hands. Something, once used for something, now used for something else. Something covered but not hidden.

TREASURE BEACH

In the 1920s, Russian film workshops would write scripts, set up scenes, and direct and act them out; but, due to shortages of celluloid, there would be no film in the camera reel. Perhaps these are some of the greatest films ever made.

More than the work itself, its form, its genre, its existence in tangible form, what interests me is the secret channel that connects the work to other work. Tarkovsky calls it "poetry," this link that allows different kinds of excellence to understand one another. I think this is the best word we have for it, although that very word "poetry" is, in English, debased and sometimes taken to mean the mere communication of sentiment.

Nothing that remains solely within its genre succeeds as poetry. When I make a work, no matter how small, no matter how doomed to be forgotten, only its poetic possibility interests me, those moments in which it escapes into some new being. If everything else succeeds but the poetry fails, then everything has failed. Poetry is precisely that which can be translated in higher (or perhaps I mean inarticulable) realms. When one encounters these diverse forms of poetry, there is a certainty that they are mystically related to one another: everything is there, everything, everything except the proof, like those Russian films from the 1920s made without celluloid.

SÃO PAULO

Something with bars, like a cage. Something like a fox, something like a wolf, but scientifically neither, a chimera. It was all attention, at least it was honest that it was in an in-between state, unlike we foolish ones who take ourselves for finished things or, worse, for final states. I took other photos that day, for example of the giraffe in its enclosure with an informational sign of a picture of a giraffe in the foreground. But it didn't really work as a photograph, nor did my image of flamingos behind a sign with a photo of flamingos. But this large canid (scientific name: *Chrysocyon brachyurus*) had tension, mystery, the unhappiness of looming extinction. Alert, with slightly too long legs.

It was a Tuesday. Only school groups were at the zoo, school groups and one strange solitary visitor with a camera. Bright sun to begin with, but then it rained. I was in São Paulo on a mission to find an old photograph, but the new ones kept coming, like tropical rain through a roof gutter's spout, including this "maned wolf," a sign for itself.

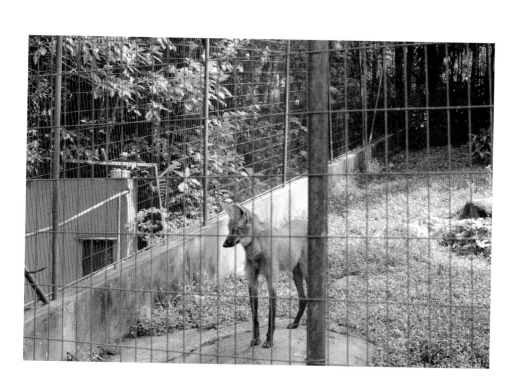

SÃO PAULO

A camel as well as a leopard: in other words a chimera. It's true that on that day, I didn't take a satisfactory photograph of the giraffe in its enclosure as it moved about in what really appeared to be a serene and mysterious slow motion. But then I went to the cafeteria at the zoo, and there were the giraffes again, set into a new truth, their camelopardalic strangeness finding an answer in the unexpected setting. Giraffes travel far, have traveled far. There was Zarafa, given to Charles X by Mohammed Ali in 1826. There were the many little carved giraffes I saw for sale in the villages of Bali, wooden and painted in their incongruous hundreds, where actual giraffes had never been seen, a perfect illustration of how certain miracles of the kingdom animalia had become a shorthand for the artifacts of the international tourist trade. Long throat, spotted body, one thing made of many.

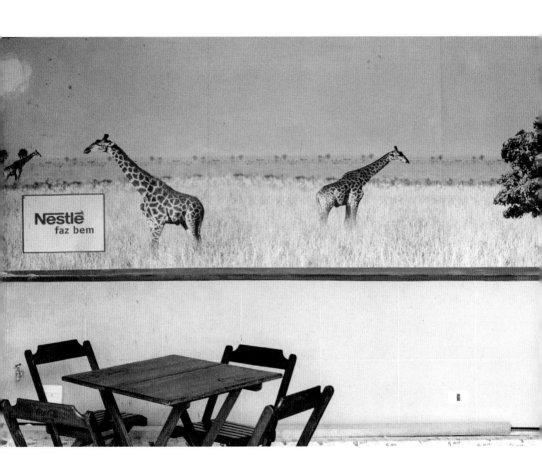

BEIRUT

Something needs doing around the house, so M's mother calls their handyman, M tells me. He isn't there, the phone is answered by someone else. It's the handyman's brother. He's away, the brother says, but I can do the work. Away to where? He's in Syria, he's become a fighter.

The brother comes and does the work.

Something else needs doing a month later. M's mother calls the handyman's brother. The handyman himself answers. You're back? I'm back. And your brother, where is he? He's in Syria, fighting. I'll come over and do the work myself.

SEOUL

The talk that morning was all of THAAD, the two-tiered ballistic missile defense system in which Lockheed Martin had a major financial stake. The U.S. and South Korean governments were in high-level talks about deploying the system, said Lockheed Martin. The South Koreans denied any such talks were taking place, and the Pentagon denied it too. On the twenty-first floor of the Hanmi Pharmaceutical company, the beautiful young employees come and go in their soft dark suits. They drink coffee and show one another interesting things on their Samsungs. Their laughter is mellow and rich, their hair just so. Suddenly I am alone in the staff lounge. Below, the enormous city, awakening to its day. Thirty-five miles north is the rupture in the terrain, the horror state.

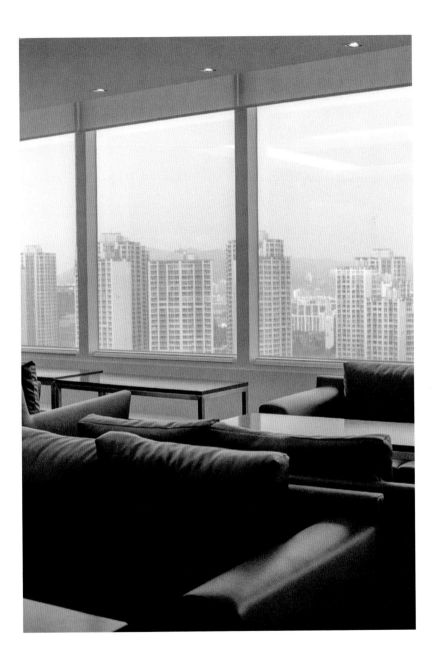

BRIENZERSEE

I opened my eyes. What lay be-
fore me looked like the sound of
the alphorn at the beginning of
the final movement of Brahms's
First Symphony. This was the
sound, this was the sound I saw.

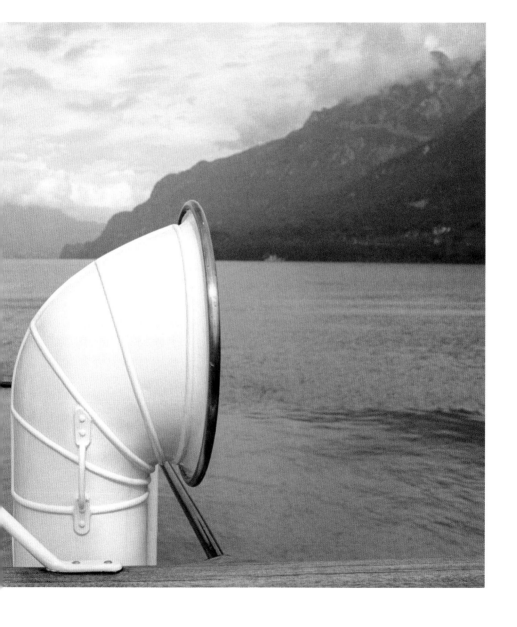

CHICAGO

Voice is not some unbounded originality: it is the gradual cohesion of what one repeats. Style is formalized obsession. The move is from "that is that" to "that is me."

> How I got into it I cannot clearly say
> for I was moving like a sleepwalker
> the moment I stepped out of the
> right way
>
> —Dante (tr. Heaney)

FORT WORTH

A woman with red hair and a man in a purple sweater paused, for the briefest of moments, in front of Caillebotte's *Paris Street; Rainy Day*. The painting was on loan to the Kimbell Art Museum in Fort Worth. The couple were in their late seventies or early eighties, and they had an easy manner with each other: not only were they together, they liked being together. They were the same as the elegant couple huddled under a black umbrella in Caillebotte's monumental painting. In fact they were that couple precisely, I swear it, only they were a little older now. They glanced at their painted doubles without really saying "Yes, it's us" or "No, it's not."

Later that day, outside the museum, I was given a shadow and its ladder crossing each other on the way to heaven, confirmation of what I had seen.

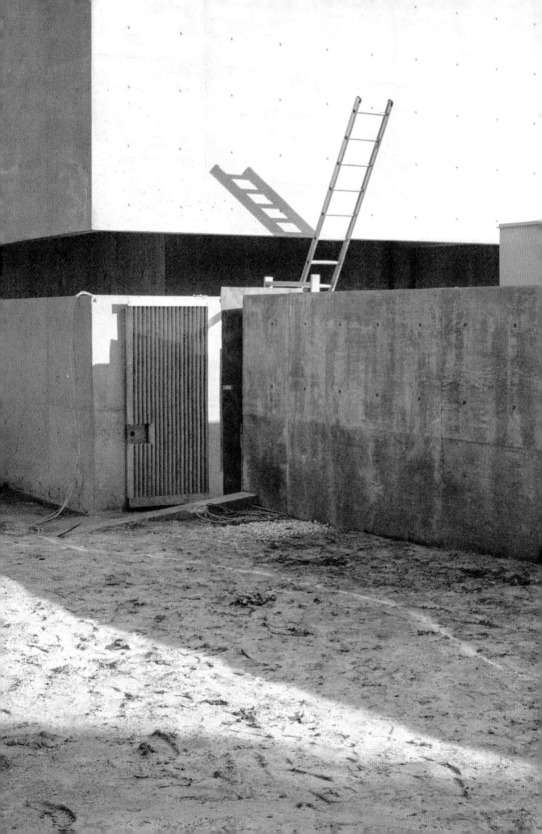

SÃO PAULO

The mask of childhood covers everything but the eyes. A woman who
had been sent to interview me asked a question that was like the sudden
realization that a mirrored wall has been double-sided all along. She
asked, though these are not her exact words: Isn't all the work part of a
single piece? She asked, like someone patiently unlocking, with a pin, a
pair of handcuffs: Aren't all the photographs and texts, the fragments
and experiments, even the things you say into a microphone, even the
things you don't say, aren't they all installments toward a unified proj-
ect? She said, though these are not her exact words: I have always felt
that *Open City* was one way you approached the problem. You're still
circling the problem now, she said, obsessed, she said, and approaching
it in other ways. You will probably always be returning to it, she said,
making herself comfortable within the folds of my brain. But it is the
same problem, she said, though she didn't directly say what the problem
was, or with what degree of success or failure I had approached it
so far.

FERRARA

Only later did I see what was at stake. I had assumed that the image was merely saying something about the unsteady boundary between the real and the painted. The mural was a window out into the cityscape. Not until a year later, on closer study, did I understand that the real doubling was elsewhere. But as obvious as it was, I didn't see it until I saw it: the way the table on the left announced a phantom cityscape of its own, in homage to the old city of Ferrara, grouped glasses for towers, porcelain houses, to the mimetic extent of the plastic water bottle campanile.

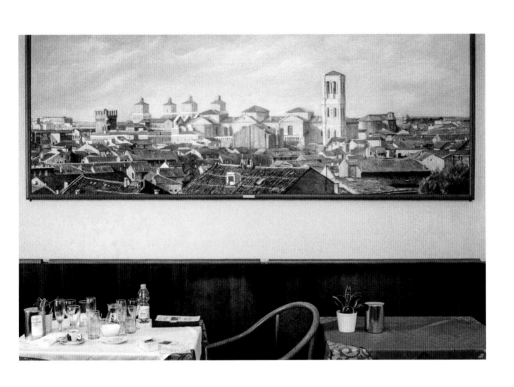

VANCOUVER

On the longest day of my life, I traveled across both the Equator and the International Date Line, arriving like a weird traveler at the beginning of a day I had nearly ended already. I was on unceded Indigenous land belonging to the Coast Salish peoples, the territories of the Musqueam, Squamish, and Tsleil-Waututh Nations. In the water beyond, around Vancouver Island, a whale-watching ship had sunk the previous week, and five people had drowned. The city glowed like an undersea creature my first night there, my day ending for the second time that day.

VANCOUVER

In some of my dreams I fly. In some of my dreams I fall. Both sometimes appear together in the same dream, and my body leads me there by some respiratory change, faster breathing or slower. In life, we seldom fall, but fly often. In dreams, we fall often, and fly seldom. Life and dream balance on this breath. In *Don Quixote*, there's the young girl who often dreamed of falling down from a tower and never coming to the ground. She would wake from the dream to find herself as weak and shaken as if she had really fallen. On a recent flight, I fell asleep, and dreamed of falling. Then I heard the captain's voice, and woke up inside a world of cloud and a soft descent, and was as shaken as if I had really fallen.

BEIRUT

At the National Museum of Beirut, as in any museum of archaeology, there are shards, sculptures, and plinths eroded by the centuries. Marble is hard, but not invulnerable. But at this museum are also ancient mosaics with very recent damage: mosaics shattered by artillery fire during the civil war.

I am arrested by a Phoenician tribune or altar of the fourth century B.C.E. It has been carved in a purely Hellenistic style. In the lower of its two frieze registers, dancers process across the four sides in high and bas-relief. They move across the centuries to silent music. The grace of the bodies is preserved but all the faces have been knocked off.

In his speech, Nasrallah addresses and does not address Badreddine's death in Syria. We fill in the gaps from what is not said.

Who defaced, so meticulously, each dancer in this frieze? It is ancient damage in this case. But it couldn't have been the earthquake that hit Sidon in the late fourth century (an earthquake is not a precision weapon). Nor could it have been the use of the site as a limestone quarry, for quarrying requires vaster quantities of stone. More likely it was the Christians. They banned the cult of Eshmun and built in its place a church. They chipped away, with theological precision, each dancer's face.

The collection is also what is not there. Museum of wounds.

QUEENS

Dickinson presents, as an instance of the tint she cannot capture, "The eager look—on Landscapes— / As if they just repressed / Some Secret." A cityscape often seems to bear a different look: voluble, confessional, full of ghostly rooms now facing out into the street. In the city, there is no shortage of stories, no scarcity of divulged secrets, only (it sometimes seems) a dearth of ears.

BERLIN

I was waiting to get a haircut at a Palestinian place on Turmstrasse. Outside, a young man had fallen off his bike, maybe he had been hit by another biker or by a car. There had been no noise, but he now lay on the ground like a dropped napkin. He seemed to be in no great pain, and I thought he'd get up. But something had happened to his left arm. My barber called the emergency services. To some people who had gathered to help, he indicated that his arm had gone limp. The man lay on Turmstrasse for almost twenty minutes, and the helpless crowd grew bigger. Finally the police arrived. My barber was furious. "The police arrived first, of course!" Then an ambulance arrived.

A few days later I was near Nollendorfplatz, when a bicyclist collided with me. The fault was mine, mostly. I realized almost too late that I was standing in the bike lane. I saw him bearing down on me, and I stepped quickly out of the lane. But he was an inexperienced rider, and he wobbled, swerved, and, though I was now out of the bike lane, crashed into me. The front wheel hit my shin. For days afterward, my leg was swollen and I walked with a limp.

WANNSEE

I was hiking in a foreign country with a friend of mine. I had known this man for years, and our friendship was mostly laughter. We were close. Something had made me nervous on the trail. There were loose rocks here and there, and a steep drop. Late in the afternoon, when we were tired, and I was hiking a little bit ahead of him on a narrow mountainside pass, but not out of his sight, I heard a sharp yelp behind me. It wasn't a scream. It was a sudden cry of surprise like a dog might make when someone kicks it. I spun around. He was gone, he'd lost his footing and plunged down the cliff to the rocks below. I gasped in disbelief, but no, this was real. Sudden, shocking, and real.

I remember nothing else, except that I was vaguely aware that shock had unbalanced me and made the trail even more dangerous for me than it had been. I managed to hike down to safety, trembling all the way. Then, later, the flight home, and crying out loud on the flight, because I didn't know what I would say to this man's wife or his child, and because I was also shattered for my own sake, full of grief at his absence from my life. I woke up sobbing.

A dream. Unfamiliar pillows in a too dry room. Bad night. Much happens in dreams that tests the boundaries of believability, and tests them in meticulous psychological terms, eventually bullying us into belief. Waking life itself becomes freighted with the psychosis and anxiety of dream events.

It is why we immediately compare the horrifying thing to a dream. The world of dreams is where many horrifying things already happen routinely. Even in a dream we say, "Is this a dream?" and sometimes falsely respond to ourselves that "No, it is not a dream"—as happened with my friend on the hike, when after brief disbelief I came to believe he really had died.

The soul cries wolf often, or has wolf cried at it.

Then one day the wolf appears for real.

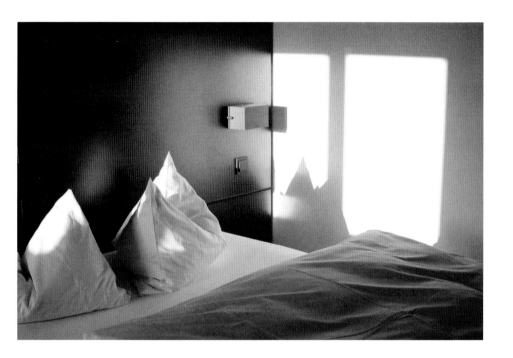

VALS

Windless day. Optical bliss. Many years later, and only in the current century, the government agreed to a fund out of which they would be paid, these now grown children who had been taken from their families, tens of thousands of them, and placed as slave labor in farms all around the country, the Verdingkinder as they are known, the contract children, back when Switzerland was not as rich as it now is. The fund was about half a billion francs. What it could not salve was the memories for these children of unmarried mothers, these gypsy children, these poor children: the angry shouts, the cold nights that cut like a blade, the hatred we naturally bear toward the weak and helpless, the terror of the long days in those mountains with their rough stones and vertiginousness and mocking beauty.

SAINT MORITZ

Movement in the peripheral vision is easy to observe. Even when you fixate on a central static point, that peripheral observation continues. However, if the peripheral stimulus is regular, it soon fades away, and becomes invisible. The effect, known as Troxler's fading, is easy to demonstrate. It is so named for its discoverer, Ignaz Paul Troxler, born in Switzerland in 1780. Let us say Troxler's fading has consequences, by analogy, for political thought. Movement in the margins is not enough. Regularity becomes invisible. You switch up the moves, you introduce irregularity, in order to maintain visibility.

Troxler was a politician in addition to being a physician and neuropsychologist. He played a leading role in the Swiss adoption of a more liberal constitution in 1848, a constitution deeply influenced by the American one and its language of equal rights.

The neurons in the visual system adapt to the stimulus, and redirect their attention.

LONDON

The English developed, somewhere along the way, a taste for conquering Alps. The first ascent of the Dufourspitze was in 1855, the Eiger's in 1858, the Matterhorn's in 1865. The ascent of the Dom, on September 11, 1858, is typical in its details: The climber was the Reverend John Llewelyn-Davies, Cambridge-educated classicist and prominent vicar, who went up the mountain with the help of three Swiss guides.

These were difficult climbs, and the risk involved was sufficient, in the words of one contemporary commentator, to "lend climbing the dignity of danger." It was not a theoretical danger: the Alps are garlanded with English fervor and fame, and are also the final resting places of many Englishmen, killed on the way up, or on the way down.

BAALBEK

It was strange enough getting there. The last thirty minutes of the journey from Beirut, on a road running northeast along the foothills of the Anti-Lebanon range, had us with the low mountains to our right. On that road, we were only a few miles away from the Syria border, at one point only five, and, even when we got to Baalbek proper, just some eight miles away. The war had spilled over in the past, there had been battles, though not right now. Tourism was down, down since 2011 and worse since 2015, and we were unnervingly alone for long spells as we clambered through the ruins' unsettling peace. I could not help but think: close to a war zone, all alone, and obviously foreign: this is how people get kidnapped.

A man offered me a guidebook and a Hezbollah shirt. I bought the guidebook. We sat in a café across the street from the ruins (will these ruins, as in Palmyra, be further ruined?), its proprietor's only customers. The sunlit apparition of a six-columned Roman temple rose in the distance behind a tendril-choked wall like a postcard of itself. Every village around here, the proprietor said, pointing to the mountains, has lost twenty men to ISIS. He doted on us, he was an old man, he recited poetry, we forgot to fix the prices before eating, he overcharged us 500 percent.

Baalbek, even ruined, was pure visual rhythm, was strict ritual and orderly worship diagrammed in stone. The cult of Ba'al, the temple of Jupiter, the Byzantine basilica, the mosque: the massive sacred site had been perpetually overwritten. Gods had killed gods here, and had in their turn been killed by other gods. In Nadia Tuéni's words:

> Beneath each column a sleeping star
> bursts into double novae on the peak of noon.
> Its language luminous, its gestures architectural,
> Baalbeck is a gift from the world of measures.

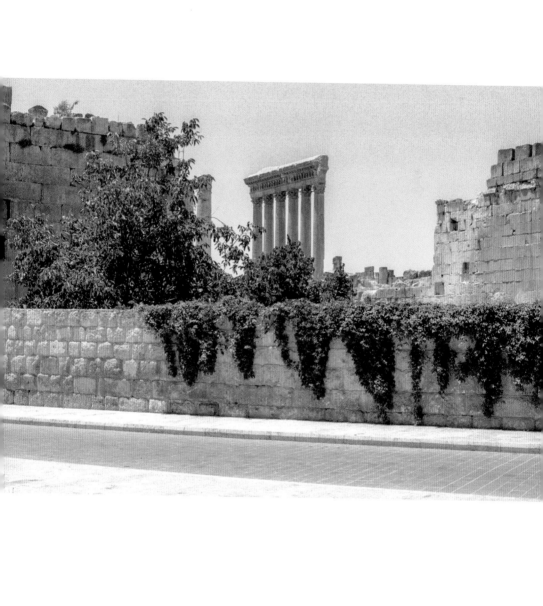

ROME

I had an interview on Rai Radio 3. M was to be my translator. She was wearing a purple coat that day. We sat in the studio, the host and M and me, and when the host asked me a question in Italian, M whispered the translation into my ear. When I gave my answer, which was usually a few sentences long, she translated it into Italian. The questions were about the book. Which had come first, the words or the images? Why were there so few people in the images? I tried to give thoughtful answers. When M, in her cool and attentive way, translated them, they sounded even more thoughtful.

She was listening to me while I spoke, closely enough to convey what I had said concept for concept, if not word for word. But what surprised me was that I was listening to her too. In the necessary silence (on my part) between my giving an answer and its relay to the audience, I had the opportunity to consider carefully what I'd just said, and what I might say next. And when I spoke, I became aware of M's attention as an active silence, like a page on which I was writing my words. I was having a conversation with the host: her questions, my answers. But the deeper conversation was between M and me, because we were translating each other's silences.

ROME

They were four, it was night. "So special, this Francis, yes, yes. But for Romans it is different." "He's a lot of talk. He talks but what has changed?" "The job of the pope is to destroy the papacy. A good pope would make sure he is the last pope." "Why?" "Too much control. Look at Rome: the church owns more than half the property in this city. It's a nightmare." "He's better than Benedict though." "(*Laughs*) Benedict was a Nazi." "Maybe so, but at least he had a sense of culture. He had refined taste. This one, this fanatical Jesuit, he has been reducing the funding for the Vatican museums." "And let us not forget: he willingly gave up the throne. Better than John Paul!" "Ma quel, Giovanni Paolo was a total gangster. (*Laughs*) A gangster. It began in the Polish resistance." "Not to mention the women." "I only heard about 'woman,' singular." "Ask the nuns! He was legendary." They opened another bottle of wine.

QUEENS

Drapery study was different. A ewer was a ewer's shape, a tree was made of leaves. But drapery represented two forms at the same time: the cloth, and the living body by which it was animated. It was a mediation between energies, a transitional liquidity: the domain of Mercury.

No coincidence then that some of the most intricate drapery studies from the sixteenth century are of angels' robes. What is angelic now? Whatever mediates, whatever ferries messages, all flow stations and through points. Inside LaGuardia, there are Hermès scarves for sale. Outside, across from departures, I see a white-robed flutter descend on the afternoon, "with ah! bright wings."

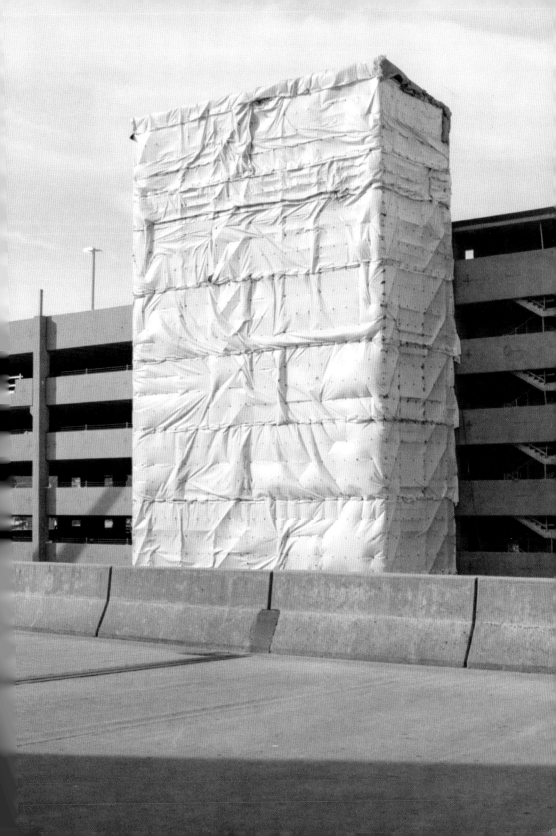

MILAN

In the late summer of 1943, over the course of two days in mid-August, Milan was reduced almost to rubble by more than two thousand tons of bombs. The British planes came in waves, shattering the bodies and homes of those below, and causing massive fires.

There are ways of showing this in photography, of showing the ruins of the city and the places where it has not healed. But what is true of Milan, and true of any city, is that there's also the scarred emotional landscape of many of its citizens, which is related to war and not related to war, and this is harder to show in photography. So we show something else.

In one interview I gave in Italy, I said to the interviewer that, unable to know one another, we must simply presume a landscape of inner complexity for each person we meet. You're talking to me about photography, I said, but perhaps you're thinking about your children or you're worried about your aging parents. I know nothing about you but must presume there's much to know. She nodded without comment. She was very professional. The interview continued for a half hour. At the end she said: You were right, by the way, there's one of my grown children I'm very worried about just at present.

When we look at a small scene of inanimate or vegetal objects, and these objects appear to be striving or under pressure, we don't literally see the emotional landscape of individuals within the city, nor do we see something that is definitely typical of this city rather than that city. We do not see the strain, the raw wounds, the inner fires still burning, or the scars. What we do see, with luck, is something that can work by analogy, as in the work of the poets.

TIVOLI

Years of winters froze into one another. Four students died: suicide, heart attack, two in a hit-and-run, all girls. One semester I witnessed two breakdowns. Then spring came and the glaciers retreated, leaving us riven with valleys.

OLD GOA

I swear he just suddenly appeared. The angel is the one who communi-
cates between realms. Hermes, medium, channel between things, gath-
erer of potentials, the flow station of being. Is this Indra, who was as
precocious as Hermes was, borne on the winds as Hermes was? Or is
it Ganesh, messenger of the gods, opener of roads, first port of wor-
shippers' call? Out in the sun that day, some kind of Catholic procession
was going on, raucous around the old cathedral, but inside the café of
the Datta Prasad Hotel, a hermetic air reigned. I raised my camera
slowly. His glance took hold of me.

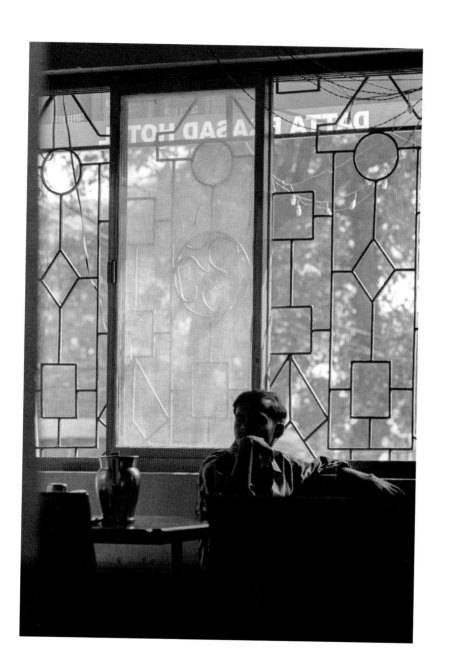

BEIRUT

The Poets light but Lamps—
Themselves—go out—
The Wicks they stimulate—
If vital Light

Inhere as do the Suns—
Each Age a Lens
Disseminating their
Circumference—

 —Emily Dickinson

Poets die. They must. But the poems, if vital, give a light that each future age refracts in its particular lens. No, not "give a light": they "light inhere": contain in themselves a light from which they cannot be separated. Like the sun, they illuminate and yet remain perpetually illuminant.

Another poem of Dickinson's, "The Tint I cannot take—is best"—which I didn't know or don't remember—cut me to the quick in part because, a couple of weeks ago, I developed a roll and found it empty: thirty-six lost shots. I had failed to engage the sprockets in one of my manual cameras. And so each time I framed a shot and clicked the shutter and advanced the film, I was fooling myself. Well there it was, an anxiety dream come true.

But Dickinson's poem, luxuriating in optics, also contains the line "The fine—impalpable Array—That swaggers on the eye." I take this as a reminder that what is seen is greater than what the camera can capture of it, what is known is finer than writing can touch. My eye was swaggered upon. I wasn't fooled.

ROME

"Obscure" is an adjective first attested in English around 1400. It means "dark," or, figuratively, either "morally unenlightened" or "gloomy." It comes from the Old French "obscur" or "oscur," which means "dark," "clouded," "gloomy," "dim," or "not clear," and is attested in the twelfth century. The French term is directly from the Latin "obscurus," which means "dark," "dusky," "shady," or, figuratively, "unknown," "unintelligible," "hard to discern," or "from insignificant ancestors." The word's roots are from "ob," "over," and "-scurus," "covered."

BROOKLYN

Your progress is not a line, direct or winding, from one point to another, but a flickering series of scenes. A street is not only its tarred surface, the buildings alongside it, the cars fast or slow, the people around you. It is also the way those things relate to one another, the way they combine and recombine. As some elements slip out of view, new ones become visible: you are moving, the cars are moving, other people are moving, even the sun is moving, slowly, and in the middle of this multi-dimensional movement you must decide when to press the shutter, decide which of these rapidly refreshing instants is more interesting than the others around it. A second before, it has not yet arrived. A second later, it is irretrievably gone.

BROOKLYN

A minute earlier. There she is on the right, walking. For now, her hair is darker in color, the jacket is almost black. Dark shoes. She's a small detail in this photograph, but significant because, a minute later, she'll have her close-up. Significant in retrospect. But I want to think about walking once more: Hermes's winged feet, Oedipus's swollen foot, Achilleus's heel, Christ's pierced feet. Walking is not easy. The Sphinx's riddle to Oedipus is all about legs. Oedipus: walking along like a street photographer when he meets the father he doesn't know is his father at the crossroads (Hermes is the god of cross-purposes) and kills him. Now we know: Labdakos ("lame"), father of Laius ("left-sided"), father of Oedipus ("swollen foot"). Trouble walking, all the way down the lineage.

A photograph, which cannot contain all that swaggers on the eye, can at the same time reveal what the photographer did not see at the time.

NEW YORK CITY

The Greek fleet was ready for war, but there were no winds, and they could not set sail. Why were there no winds? The goddess Artemis's anger was turned against them. Agamemnon had killed a doe sacred to her, in her sacred grove in Aulis. There would be no winds, and no sailing, and no war, and no destruction of Troy, until she had her satisfaction. Agamemnon agreed to give away his daughter Iphigenia to Artemis as a sacrifice. (Men are always giving women away.) In the scene the great painter Timanthes painted of Iphigenia's departure, Calchas was sorrowful, Odysseus was more sorrowful, and Menelaos was overcome with sorrow, all of which Timanthes portrayed with stunning accuracy. But the father Agamemnon's grief was greatest of all, a shattering extreme of grief, and Timanthes could not, or would not, go beyond the limit of what he had already shown. And so he depicted Agamemnon without depicting him: turned away, with a veil over his head.

NEW YORK CITY

I last walked in there on September 9, 2001. Since then, I've gone near it many times—in taxis on West Street, on foot on Greenwich Street, by Trinity Church—but have been unable or unwilling to go into the plaza. Thirteen years pass. I finally return, in May 2015, with the camera as a mask. The fusion of dream and reality into a single reality. Painters like Hammershøi and Vermeer know the power of this gesture. One turns away to show what cannot otherwise be shown. The sense in turning away. The power of a gesture that speaks without being spoken to.

CHICAGO

I pray to Tarkovsky, Marker, and Hitchcock. I acknowledge the dumb skull, the verso of the face, the local globe from which all thinking originates. I pray to Ojeikere and Richter, in whose works someone is always turning away. In certain pictures, we can verify a character's presence, but, without the clues of the confessional face, not what the character thinks. What has turned away contains itself. A stone contemplates a stone. *Stalker*, *The Mirror*, *Sans Soleil*, *Vertigo*. Multa pinxit, hic Brugelius, quae pingi non possunt, wrote Ortelius. He painted many things, this Bruegel, which cannot be painted. What cannot be painted?

NEW YORK CITY

What is he saying? To whom is he talking? He is secret in public. The hood is extra secrecy, like the veil Timanthes puts over Agamemnon. The phone box frames him in a way that makes me think of a prisoner whose singular lifeline is the telephone that reaches the outside world. Minutes later I will encounter the blond woman in green. But I don't know that yet, she's still in the future. Who in these days still uses a pay phone? There are still pay phones? Is he calling someone collect? (Again, I think of imprisonment.) The one to whom he speaks cannot see him: speech without a face. Why do I feel I have seen him before? Marker says remembering is not the opposite of forgetting but rather its lining. Imagine, for a moment, that every face you cannot see is your own face, but years later. The future is lined with your future face.

TIVOLI

We liked the house. We liked the terms. They would be away for a few months.

 Their mother was still alive in September, living in the house, then Death took her. (Their father had died in 1986.) We moved in in January. Funny place. Knickknacks everywhere. Things askew. On the mantelpiece were two urns, containing their parents, there when we woke up, there when we went to bed.

NAIROBI

I was about a mile away, giving a reading at the National Museum. "The crackling report of brens / and the falling down; / a shout greeted them / tossing them into the darkness." Word of the attack filtered in. Oblivious, I continued taking questions from the audience, including one about "the precariousness of life in Africa." I was at the museum and he was at the mall, because my reading was scheduled earlier and his later. It could have been the other way around. Our conversation could have ended with my death, not his. A question of scheduling. Many people died there that day, one mile away, "in a gush of gore, in a net." The death toll is always one, plus one, plus one, plus one. The death toll is always one.

ULUWATU

We build, we correct what we have built, we break down what we have built, we build again, and correct again. Deconstruction is no more real than continuous construction. Things accrue. Renovation is the city's fact. It is the universal language, the second of the two seasons.

My grandfather was a schoolteacher, but he supplemented his income with the sale of construction materials. Those things were in more or less orderly piles in front of his house in a small town in Nigeria. For many years in the early eighties, I played among those things, and their latent potential was an early part of my imagination.

Renovation extends a hand toward a future unseen but longed for. This much effort, soul says, might translate into this much shelter, into this much supporting wall, or even into this much money (if the one that builds builds for another). I see in each construction site, particularly in the small ones, a gesture of hope. To construct, to repair, is to hope. Who is to say those bags of cement at their slumber are not the material trace of some deep personal dreamwork?

BCHARRE

In the afternoon, just before we reached town, after we'd been driving for hours, we stopped at a sleepy little café for coffee and water. The café was on the same street as a shuttered club, an equally sleepy-looking restaurant, and some houses under construction or in disrepair (it wasn't always easy to tell which was which).

The café, which was itself also a restaurant, was on the lip of the gorge, and outside were two men drowsing in the sun, talking little. One stood up to ask what we wanted, and we went in. Coffee arrived. The restaurant, split level, was next to a small but hectic rapids. It was noisier downstairs, too noisy to hear each other, so we stayed on the terrace upstairs, underneath a red awning, overlooking the gorge and the cascading young river, and drank our coffee, and drank water from the source.

The proprietor, or manager, was friendly, and he introduced himself as Mr. S. He wore a suit, and there were no customers. His pate shone. It was perhaps three in the afternoon, not too hot a day. The big painted sign above the restaurant read, in all caps and individual letters, "MISSISSIPPI." The letters were pink, sustained by an exoskeleton of painted green poles. It was a striking, movie-set-like apparition against the forested and pale gray mountain behind. We asked about the origin of the name, and Mr. S smiled and pointed to the rapids.

He talked for a while. There wasn't much company around, and he was fascinated by his visitors. He kept praising A's Arabic. He and our driver, whom we called the Pasha and who had come in with us, regarded each other a little warily. Mr. S brought us some sweet ikidinya fruits (loquats), which we ate, and then we paid and left.

Why then did I feel a pang of loss when we left the Mississippi that afternoon? Mr. S stood by the door, smiling, waving us goodbye. We'd drunk water from this Mississippi, and were on our way.

What is the meaning of a solitary man standing in a doorway in a faraway place (far away from where?) and seeing for the last time some visiting strangers? He doesn't know where they've come from, all he has are the names of cities, and he doesn't know where they're going. I make excellent kibbeh, he'd said to entice us, come for dinner, but we knew we wouldn't return.

But do not hurry the journey at all.
Better if it lasts for years . . .

Mr. S in his careful suit, dressed up for no one, smiling at the edge of a small town in the eastern part of the country. We went on to a hermitage, a museum, forested valleys, but already it was this stop, for coffee and water, that was charged with a mysterious poignancy.

And then what? The afternoon waned and we had our fill of sights but not enough to eat. The Pasha drove us through Bcharre to find a place for dinner. He parked somewhere, we walked around. Nothing was open.

We pulled up at the Mississippi. Mr. S was outside. His face lit up like a lamp. He began to laugh, he began to applaud, and, helpless before his joy, we began to laugh too.

Mr. S disappeared through a door, emerged minutes later. Glorious fattoush, its toasted pita cradling the sour sumac, airy hummus, baba ghanoush of brooding smokiness. No despot, no emperor in time immemorial, was ever more grandly served than Mr. S served us three that evening. The dishes arrived in quick succession, like magic tricks, like something long in the planning, deployed with precision and ferocity. He was smiling, laughing, almost prancing with joy. He was alive in

his suit. The greatest meal in the world. The best chef. The happiest eaters. In the middle of nowhere.

He'd tell us what came from where, the terroir of this, the source of that. Olive oil from the south, wine from the Bekaa Valley. The water was from the local Mississippi. Have you seen *Babette's Feast*? This was the Café Anglais reborn in the Qadisha Valley. The manaeesh was festive, florid. Remember *Big Night*? Not even Primo could have made kibbeh so true to itself. Lamb brochettes.

The sun went down. Out came flan. Fruit, more ikidinya. Coffee. Other details I forget. "Iridescences which are not of this world."

I insisted Mr. S get a glass. I poured him some wine, and we toasted the immortal meal. He took photos with us. When we paid, he looked away, abashed. We paid too much and not at all enough. We were still laughing when we got into the Pasha's Toyota and made our way to Hadath El Jebbeh for the night. That was it. Now we knew. That was the meaning.

ZÜRICH

Kitchen to living room. Bedroom to bathroom. Downstairs to get the mail. House to subway. An evening stroll. You take around 7500 steps each day. If you live to eighty, in-shallah, that comes to 200 million steps over the course of your life, a hundred thousand miles. You don't consider yourself a great walker, but you will have circumnavigated the globe on foot four times over. Downstairs to get the mail. Basement for laundry. Living room to bedroom. Up in the middle of the night for a glass of water. Walking through the darkened house, you suddenly pause.

VENICE

They must have known they were being watched, the African guys doing a brisk trade in Prada and Gucci bags. They were young, personable as was required for sales, but at other moments suffused with melancholy. Late afternoon. Beautiful yellow light enfolded the city. The bags sat. There was a sudden commotion: with a great whoosh the African brothers raced up the steps, their bags gathered up in white cloths caught at the corners and converted into bulging sacks on their backs. One after the other, they fled upward. Tourists shrank out of their way. I spun around, pressed the shutter. (But that was another photo. This one, taken years later, in Venice and not in Rome, was the uncanny echo.) Far below, carabinieri arrived, but by then my brothers had gone, these last angels vanishing up the long flight of steps, "a hurry through which known and strange things pass," their white wings flashing in the setting sun.

ROME

After a number of modulations, the song returns to home key.

We were in a place and a stranger asked me a question. I answered. Then she asked another, and this second question made it clear she thought I was a worker at the place, a janitor or custodian, and not, like her, a guest—not, like her, an intellectual guest.

I said, "I'm sorry, I don't work here. Like you, I'm . . . ," and I saw in her face first incomprehension, then once she'd comprehended—once her imagination finally allowed that I could be that, that I was in fact that just as much as she—a flicker of dismay that she'd got it wrong. The next day she had done her research, and found me, and sent an email. It was a rapprochement, not an apology; but an apology wasn't needed, not for something so mild. She seems like someone I'd like.

Summer lawns. The days white as new pages, page after page. Empyrean. Mornings of a life. I made this photograph in Rome, maybe or maybe not in the vicinity of the little, barely there, story.

Finally it's not what one person does to another, it's not usually that. It's the superstructure of the way we understand "other," but even if life is only properly understood in the general, it must be lived in the particular.

My heart, there is so much that can be neither spoken about nor left unspoken. After a number of modulations, the song returns to home key.

SEOUL

You told me to see Gyeongbokgung, Myeong-dong, and Gangnam. Just now, as I write this, I thought of how close they'd come to killing you, that first time you'd made your way out of North Korea. And the second time too, when with your heart of a lion you had gone back in to get your mother and brother. Who does that? But you did, a mission almost certain to fail, a mission you took knowing that failure would have meant death for all of you. At the checkpoint, once you'd crossed into China, you spoke fluent Chinese, pretended you were taking deaf patients to an institution. How close the absolute disaster came that time—but the ruse worked. But there you are now, laughing as you walk away from me, "I hope you like fifty percent of my country."

NORTH CHARLESTON

Friends drive me from Columbia to North Charleston. Across the street from Advance Auto Parts on Remount Road in North Charleston, where two men parked their cars on April 4, 2015, and one of them, a cop, gave fatal chase to the other, an unarmed civilian, is a Filipino restaurant called Luz's. I went in, had a coffee and some sweet potato fries. The owners, Luz and Cecilio Monroy, have been married forty-eight years. I'm drawn to the maps and globes that decorate the restaurant. The world circumnavigated. I am at Luz's Place that day when I remember that late Mr. Scott, the unarmed civilian, and his murderer, Michael Slager, the cop, were both veterans of the U.S. Coast Guard. See the world, they said. Always ready, they said.

GEMMIPASS

In 1891, Sherlock Holmes and Dr. Watson crossed the Gem-
mipass, more than two thousand meters above sea level, on
the way to Holmes's fateful meeting with Professor Mori-
arty at the Reichenbach Falls.

It was up here, having narrowly escaped a fatal fall, that
James Baldwin figured out what to call the novel he was
working on: *Go Tell It on the Mountain*.

LAGOS

All the cities are one city. What is interesting is to find, in this continuity of cities, the less obvious differences of texture: the signs, the markings, the assemblages, the things hiding in plain sight in each cityscape or landscape: the way streetlights and traffic signs vary, the most common fonts, the slight variations in building codes, the fleeting ads, the way walls are painted, the noticeable shift in the range of hues that people wear, the color of human absence, the balance of industrial product versus what has been made by hand, greater or lesser degrees of finish, the visual melody of infrastructure as it interacts with terrain: wall, roof, plant, wire, gutter: what is everywhere but is everywhere slightly different.

ZÜRICH

We can imagine optical illusions because we have experienced them. Moral illusions are more difficult to imagine but are no less real. Moral situations arise in which we are unable to correctly interpret the information in front of us.

You might see a map of a bombing raid, for instance, with the note "Each dot represents 500 people," and proceed thereafter to enjoy a nice lunch or a piece of music.

The invisible armature of the world as we live it is a series of extinction events, the ones that have happened, the ones that are to come.

McMINNVILLE

What she said when I mentioned that I had recently been to McMinnville: McMinnville! I know McMinnville, when I was a child, my mother used to drive us all, four hours going and four hours back, to visit my father during the years he was imprisoned there, for a variety of small offenses that cumulatively became significant.

TIVOLI

Last night at dinner, she told me that R is losing his vision. I was stunned. Him of all people, so young, so good at seeing. Really one of the best at seeing. "That's why he's been working so much," she said. "That's why he's trying to see everything, trying to cram it all in before it's too late."

TIVOLI

In 1871, when he was thirty-six, Degas developed the retinopathy that was to afflict him all his life. At the age of thirty-eight, he wrote to Tissot: "My eyes are fairly well but all the same I shall remain in the ranks of the infirm until I pass into the ranks of the blind. It is really bitter, is it not? Sometimes I feel a shiver of horror." The following year he wrote, again to Tissot: "My eyes are very bad. The oculist has allowed me to work just a little until I send in my pictures. I do so with much difficulty and the greatest sadness."

In the spring of 2011, shortly before I turned thirty-six, after a brief episode of blindness, I received a diagnosis of papillophlebitis and underwent surgery to repair a number of perforations in the retina of my left eye. The photography changed after that. The looking changed.

LAGOS

Pliny describes in the thirty-sixth book of his *Natural History* one of the remarkable illusionistic mosaics of antiquity: "Pavements are an invention of the Greeks, who also practised the art of painting them, till they were superseded by mosaics. In this last branch of art, the highest excellence has been attained by Sosus, who laid, at Pergamus, the mosaic pavement known as the 'Asarotos œcos;' from the fact that he there represented, in small squares of different colours, the remnants of a banquet lying upon the pavement, and other things which are usually swept away with the broom, they having all the appearance of being left there by accident."

THE FOREST OF THE CEDARS OF GOD

Photography is good at showing neither political detail nor political sweep. Politics is a matter of discourse and discursive compromise. Photography can show violence and its aftermath, it can show laughing faces, or romantic sentiment. Photography is quite good at metaphor and at evocation. But politics is elsewhere, hard to compress into a rectangular frame. At best, a photojournalistic image can show some of the theater of politics. In the process, it can bowdlerize what is political about politics. Unfortunately the public often reads this as political truth in itself.

In Lebanon, I paid attention to what was going on around me, in different registers. I came to some modest understanding. But how do you depict Maronite politics, or Sunni politics? What does a photograph of the Syrian Social Nationalist Party look like, or one of Amal, the Shi'a party, or the Druze party? How do you show Hezbollah in a photograph?

But this difficulty does not prevent news photography from making claims, nor does it keep those claims from being accepted.

QADISHA VALLEY

Oil drums and concrete pillars demarcate the boundary of an uncompleted house overlooking a gorge in the Qadisha Valley.

"A picture is worth a thousand words" is a category error. No one thinks of saying a song is worth a hundred dances. Certain songs are fine to listen to by themselves, but certain others, equally strong, gain something when a dancer rises up to meet them.

Rosalind Krauss has written of the role of spacing in the surrealist image. At first by means of collage, but also by means of the found scenario, the surrealist photograph shows things sequentially. Their role not as marks of reality but as signs becomes emphasized. This comes about because of the spacing, and the charge the spaces generate.

What work are the words in this book doing? These words are excessive, the way a dancer must be excessive, must always give a little more than is necessary. The extraness of the dancer must nevertheless maintain the illusion of economy.

TIVOLI

Look down. Geology defeats geometry. A walk in town in spring, when everything is a mess, and different states of matter are in flux, is a walk through probability and chance. Euclid cannot help us here. The same logic governing continents, islands, and bays governs the puddle with its gravel, ice, sand, mud, and melting snow. All are in that family of shapes and complex hierarchical rules that Mandelbrot called "fractals." And what sees is as what it sees: the vascular tree of the retina is fractal (the last scan of my left retina showed this complex web, with what resembled like a number of small explosions).

TIVOLI

They kept asking him, "Then how were your eyes opened?" He answered, "The man called Jesus made mud, spread it on my eyes, and said to me, 'Go to Siloam and wash.' Then I went and washed and received my sight." They said to him, "Where is he?" He said, "I do not know."

SELMA

A dream in which I am crossing the street and never reach the other side. I drift. Hot afternoon in a city I know not too well. "The idea we have of the world would be overturned," Merleau-Ponty writes, "if we could succeed in seeing the intervals between things . . . as . . . things themselves."

Solitude.

I keep deferring my arrival at the destination. The destination is to arrive at this perpetual deferral, to never reach the destination. I dream all day. At night I dream of drifting.

RHINECLIFF

My eyes were technically fine, but for weeks I saw nothing worth pho-
tographing. Winter was hard. I woke up early in the mornings, 5:30. I
would listen to either Schubert's String Quintet in C or Björk's *Vesper-
tine,* and take the first careful steps on the ice toward the unspooling
day. I missed the train at times. I taught literature and art history that
winter, and I wrote essays, but lived in exile from my camera. I listened
to Beck, Sufjan Stevens, Vijay Iyer. The ears were open but the eyes
remained closed. Rhinecliff was the portal of this coming and going. I
looked, saw nothing. Then something began to develop and I waited to
recognize my face as it emerged from the tray.

SYRACUSE

The legend of Saint Lucy, Santa Lucia, has a familiar shape: the noble birth, the intersection of virginal purity and Christian belief, and the subsequent brutal execution that contains distinctive iconographic features.

She was from Syracuse, put to the sword there in the fourth century, and, in her sculpture placed high in the façade of the cathedral in that city, she holds a dish containing her two eyes. One version says she gouged out her own eyes to dissuade a persistent suitor. Saint Lucy (lux: light) is the patron saint of the blind.

Now. In the Piazza Duomo in Syracuse, between the cathedral and Santa Lucia alla Badia, I made a photograph of a curved wall. Gently curved, I thought, like the surface of an eye. When I developed the film, I saw a pattern emerge from the centuries-old water damage on the stone wall. I saw, or think I saw, a human skull, with the two orbs where, in life, the eyes used to be.

BROOKLYN

The stage is set. Things seem to be prepared in advance for cameos, and even the sun is rigged like the expert lighting of a technician. The boundary between things and props is now dissolved, and the images of things have become things themselves. Perhaps the artificer's gold paint is still wet on such scenes in which we play at kings. Wandering around, I find this theatricality of city life especially visible at the edges: the sleeping docks, the decrepit industries, the disused railroads: at such places, the city is shorn of all superfluity and reduced to its essentials, as in a play by Beckett. Flutes! Drums! Let the players in.

TIVOLI

How are things? These are the objects of and around a bus stop: amorphous banks of snow, a metal drum, a bus shelter, the pole of a sign, a wooden post, the trunk of a tree, patterns printed on Plexiglas. Brought together by the rectangular organization of the viewfinder, they move from being objects into being things. They are no longer what they were made for. Now they are functional equals on the picture plane: blue construction anchored on a rectangle, green line, gray-brown broad vertical, scatter of white and off-white here and there, chatter of pale yellow dots, red cylinder topped by dark brown oval, and so on. Each element is as insistent and necessary as the shapes and colors in a suprematist painting. Meaning comes from the collective tension and balance of these individuated elements. But this dreamwork bricolage comes by an arrangement of the eye, not of the hands. An object is used. A thing is seen.

THE FOREST OF THE CEDARS OF GOD

Plane and almond trees have mottled bark, but the patterning on poplar trees is particularly loud, almost like military camouflage.

To deceive his father-in-law, Laban, with whom he is living in Syria, Jacob makes a deal that Laban will keep the pure-colored animals, and Jacob will keep for himself only the speckled goats and sheep. "Only," but if you know Jacob, you know something's afoot.

Near the end of the twentieth century, scientists experimenting on primates described a new class of brain cells. Mirror neurons, as they came to be called, are fired both when people perform an action and when they watch it being performed. For these neurons, seeing and doing are identical. Their imitative function is thought to be key to empathy, language acquisition, and human self-awareness.

Jacob makes sure the more vigorous animals in the unspeckled flocks mate in front of an arrangement of plane, almond, and poplar branches. When these flocks lamb, the lambs come out mottled and spotted, and Jacob's share of the flock increases. Laban is furious, but God is against him.

Glory be to God for dappled things. All things counter, original, spare, strange; whatever is fickle, freckled (who knows how?)— But Jacob, contender and deceiver, knows how. He knows how streaked we are by what we see.

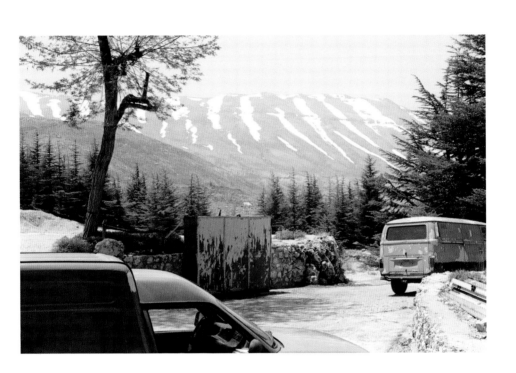

BASEL

Color is the sound an object makes in response to light. Objects don't speak unless spoken to. An object does not have a color, it makes a color (the way a bell makes a sound). Sound is molecular motion. Color, too, is molecular motion. Color is the selective absorption and emission of light on the surface of an object. As an untouched drum makes no sound, an object in total darkness has no color.

A photograph full of muted but complicated color is similar to a full orchestra playing a quiet passage: powerful resources used to create a subtle effect. With my eyes I begin to hear what I see.

MEXICO CITY

"This morning, we had just arrived at the house," she said. "There were many cats, alley cats, I guess, hanging around there. Our driver backed up and, oh my God, he ran over one of the cats. It was terrible." Her face said terrible, she was wide-eyed about it still. "You know, I'm past sixty now," she said. "And I've gotten this far in my life without seeing . . . this is what I realized this morning . . . without seeing anything, or anyone, get killed. Can you imagine that? That poor cat." I said nothing, but I've seen lots of death, of many different kinds.

Later, as she and I made our way into the courtyard of the Museo Nacional de Antropología, she said (connecting it not to the story about the cat, but to a conversation we were having about Oedipus): "I never really cared about the classics, but when my brother died, I did nothing but read Greek tragedies. They were the only thing that made sense. I couldn't stand anything else." She had just used a phrase—"when my brother died"—that contained the experience of a level of pain about which I knew nothing.

BROOKLYN

Something in the middle of a group of five. Something on the periphery: something first, something last. Something squeezed. Something brown. Something made of metal but susceptible to injury. Something designed for some other purpose. Something on the street. Something held up by others in its group. Something under pressure. Something exerting pressure. Something seen on the way to a rally in the time of Black Lives Matter.

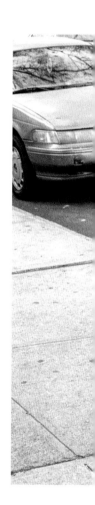

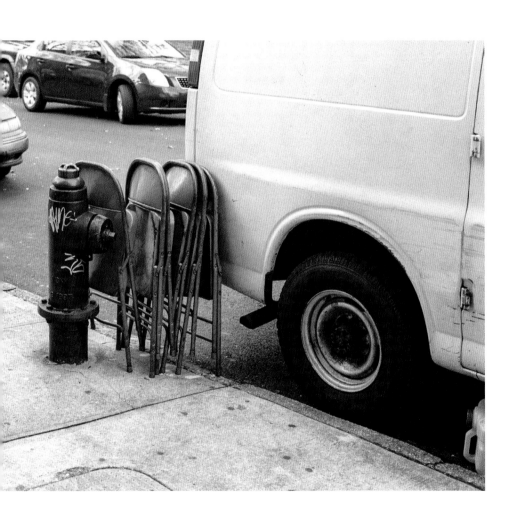

YPSILANTI

I have photography dreams in which something goes wrong. I have more of these dreams now, in the past few years, because I have been shooting primarily with film. Something happens. Something goes not right. And what happens in dreams happens in life. (This is why it happens in dreams.)

When I arrived in Florida from Michigan, I was near the end of a roll I had shot in Ypsilanti. I saw something I wanted to photograph farther along at baggage claim, something from the logic of dreams, in which the sea lies just beyond a conveyor belt. So I went there. I was alone. I focused, and made my shot. I took a second shot, to be sure. But then my hands failed me, and I dropped the camera. It clattered to the floor, and the film compartment sprang open, exposing to a flood of airport light the newly exposed negative.

I fell to my knees, closed the compartment, wound the film, and removed it. Then I put in a new roll and began to shoot again. When I developed the accidentally exposed roll, I had lost a couple of photos, as I'd feared. A few others showed evidence of light leak. In one taken in Ypsilanti, this leak intensified the latent surrealism of the scene.

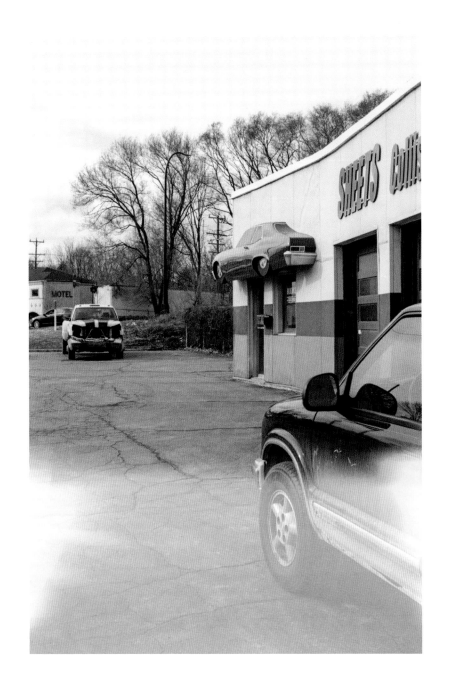

SAINT MORITZ

Somewhere in his novel *Immortality*, though I cannot now find the reference, and I last encountered it some twenty years ago, so my memory might be false, Milan Kundera's narrator says: I once wrote a book called *The Unbearable Lightness of Being*, but that was a mistake, for I should have given that title to the book you are reading right now.

Other than the sensation of magic that accompanied the awareness of a book talking past you to another book, or of the author taking into account what else you had read, I have always been haunted by this sense of the migratory properties of works, so that at times I feel as though the photographs and captions in *Blind Spot* have escaped from a novel named *Open City*, or that there are things said here, and which belong here, that first belonged in *Known and Strange Things*. This is not an avenue of thought I wish to foreclose under the dismissive term "self-referential." The continuities involved are interesting for their own sake.

The property of being distinguishable is independent of the property of being distinct—I can distinguish between my practices, but that doesn't mean they are distinct.

QADISHA VALLEY

I had parked my car in the shadow of the overhanging rock above the precipice. A man walked past my car, went past the traffic mirror and red safety notice, and stood at the edge. He appeared to be a foreigner. He stood there for a very long time, maybe fifteen minutes. He had a camera but didn't take any photos. I wondered what kind of life he lived, what his past contained, and how he came to be standing here in this faraway country, at the edge of the precipice. What was he thinking about, there ahead of me?

After taking the photo, I walked past a car parked in the shadow of the overhanging rock above the precipice. I went past the traffic mirror and red safety notice and stood at the edge of the precipice. There was a man in the car behind me, a local, to judge from the plates. He just sat there, not moving, and with no change in his expression. When I turned around and walked past him, probably a quarter of an hour later, his expression was still the same. I imagined that he came here to the edge of the precipice to get away from a difficult life, to enter into aloneness, silence, the cool of the rock's shadow. What was he thinking about, there behind me?

NUREMBERG

The elaborate nighttime parades at the Zeppelinfeld, those nightmares of an optimistic frenzy, were designed by Albert Speer. Speer also built a large transformer house (Umspannwerk) behind the Zeppelintribüne, on Regensburger Strasse, to power the massive searchlights that illuminated the parades and performances. The Umspannwerk went up between 1936 and 1939. As I passed it one rainy afternoon seventy-six years later, it looked very much as it must have at the beginning. A row of large red pennants flapped proudly from flagpoles along the front of the pale and imposing neoclassical building. On each of these huge pennants, as on the front of the building—the eagle and the swastika to the side now scraped off, but still visible as a dark stain—on the pennants and on the front of the building was a stylized crown. In addition, there were two words indicating the Umspannwerk's current use: "Burger King."

PURA LUHUR ULUWATU

Work is. The semantics of the objects used in construction, in particular, are common across countries: so common as to be rarely properly seen. At a temple in south Bali, bored by ornaments, incense, and monkeys, I worship at a construction site. The project under way, I guess, is the repair of the stone wall in the middle distance. Or perhaps the project is on some other part of the grounds. In any case, the metallic blade of the shovel, its wooden shaft, and its red plastic handle are the familiar elements of an object made for handwork. It is a reassurance, as is the green hose that brings water to the site. There's a white pail, repurposed from a commercial paint bucket. The brown paper on the left is from emptied bags of cement. A rusted pan sits empty in the back. In the left foreground, gravel, sand, and cement are mixed with water. The sand pile on the right is scalloped from the shovel's repeated bite. These are the staples of a billion childhoods around places where things were built or repaired. The situation is concrete in more ways than one. But the light-filled mise-en-scène is also as charged with the temptation to an iconological reading as any Flemish painting.

VALS

The Therme opens out like the raising of Lazarus. But this is the moment just after the miracle. The crowd has dispersed. Lazarus goes home, resumes his job. His eyes adjust to the light. His depression returns. Years pass, and he's dying a second time. It's as hard as before: he feels cold, he feels lonely. But there are no TV cameras this time, there's no newspaper notice, and there's no coming back.

SELMA

Sparky's back. The earth is red. Six hundred people, led by John Lewis, march across the Edmund Pettus Bridge in 1965. They are met by Alabama state troopers and local police in masks and on horseback. The troopers charge and, with a viciousness that can hardly be believed, batter the undefended crowd. Baldwin writes: "I could not suppress the thought that this earth had acquired its color from the blood that had dripped down from these trees."

I retrace the route on a quiet Sunday half a century later. I pick up *The Selma Times-Journal*. "Sparky the Fire Dog has returned, and he made a grand entrance the morning of the Selma–Dallas County Christmas Parade. The dog costume was stolen from a vehicle parked at the Station 3 firehouse on Oct. 20 and found weather-damaged, dirty, torn and missing pieces behind the old Pancake House. . . ."

SELMA

The problem is that he writes for *The New Yorker*. The problem is that he left Harlem and left the church. He is writing for *The New Yorker* and he is talking black liberation while fucking white boys. The problem is that he doesn't understand the urgency of armed struggle. The problem is that he is questioning the Panthers instead of joining them. Jimmy hates blacks. Jimmy should stick to writing novels: his polemics are repetitive and tedious. Jimmy is inauthentic, sexually perverse, and unmasculine.

The criticism is brutal. It gives him headaches, it makes his hair go white. So, he keeps leaving America, and not only because of white supremacy. But who remembers any of that now, now that he is a secular saint? The difficulty now is to find someone who does not reflexively quote James Baldwin. All the words we need for our predicament are to be found in him. We quote him as though he had always been universally praised. We lean too hard on his honeyed words. But in his lifetime he was extending this work, like an arm of hope, into the future, working as though he knew his work would be helpful mainly to those who had not yet been born.

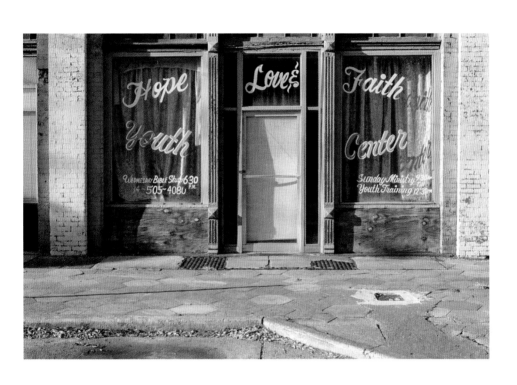

BEIRUT

My darling. They said we wouldn't cross tonight. Now they say we must. My phone is dying. There is a pregnant woman here and she won't stop crying. I will send you a Facebook message tomorrow, inshallah.

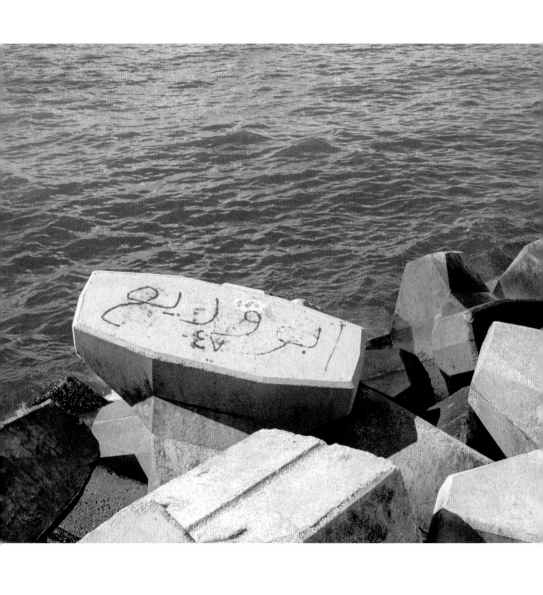

LONDON

The body has to adjust to the environment, to the challenges in the environment. The body isn't wrong, isn't "disabled." The environment itself—gravity, air, solidity or the lack of it, et cetera—is what is somehow wrong: ill-matched to the body's abilities, inimical to its verticality, stability, or mobility.

She said her husband had said their infant daughter, whose mind is conventional but whose limbs struggle to accomplish their given tasks on earth, is, in this sense, like an astronaut: far away from home, coping.

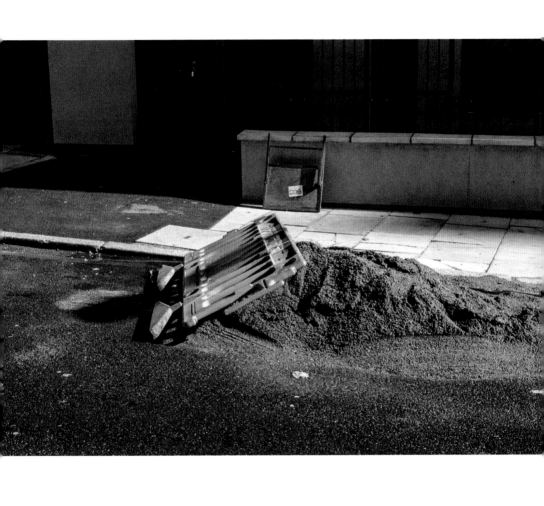

TRIPOLI

In Tripoli, I thought of Homs, which is an hour's drive away, only an hour's drive, which Death now visits. But what can this proximity mean? There were soldiers in the middle of town in Tripoli, a tank. Blast walls painted with the Lebanese cedar. I asked my friends why, and they said they hadn't even noticed. A Syrian child grabbed my arm and wouldn't let go.

It takes courage to face the open sea. It is one thing to know in theory that a boat can float, and another to entrust your actual all to it for days. The Phoenicians who lived on this coast knew the sea, were synonymous with it. The piscine grace of their seafaring craft can still be seen, at modest scale, in their descendants' fishing boats.

They were fifty-three. Some undoubtedly more courageous than others, but each was more courageous than he or she would, in tranquillity, have wished to be. This was October last year. You wouldn't have heard of it. Just another drop in the sea of stories.

The disaster is that which has already happened. The boat was built for fifteen and they were thirty-eight over the limit, Palestinians, Syrians, and Lebanese. The boat was built for fishing but now, in waters past fishermen's range, it had become a craft of crazy hope.

How does the story end? They didn't die. It hardly counts as news. The Navy stopped them a few miles out (their hearts breaking at a stymied flight, but for those whose courage had already failed the sea's interrogation, a relief too). They were towed to shore and charged with the crime of hope.

I am writing this on a flight back into New York City. The river's silvered tendrils around the fragile city. I dozed on the flight and dreamed of drowning. Forty-five minutes after my flight lands, a small plane crashes into the Hudson. It's a World War II–era plane, a P-47 Thunder-

bolt built between 1941 and 1945. Fear death by water. The pilot was fifty-six years old. In the taxi home, I write about the boat in Tripoli, a "craft of crazy hope." Had I looked up just then, would I have seen a small doomed plane arcing across the evening sky? Around 10:40 P.M., I am drifting off to sleep (am being lowered into sleep). At that very moment, the pilot's body is retrieved by divers.

UBUD

To honor ancestors, to protect the thresholds, to guide a journey, canang sari are made daily of flowers, rice, and woven fronds. They can be bought at market, but what then would be done with the time saved from not making them by hand? At day's end, they are discarded. Tomorrow new ones will be made, with precision, design, and care. These small deposits of time strew the Balinese street like repeated fragments of a melody.

LAGOS

I was around fifteen. I had myself been wearing glasses for many years. But perhaps I thought my problem was less urgent because it was less severe. The kid had Coke bottle glasses on. He was on the edge of blindness. This was at a time when God had been moving through me, saving souls with my preaching gift, raising up a band of faithful fellow students. I told him to take the glasses off. I placed a thumb on each closed eyelid. "Open your eyes. Look in the distance. What do you see?" He squinted. "It's blurry." He put the glasses back on. I explained to him that without absolute faith there would be no healing. "Do you believe that you can be healed?" "I believe." "Then be healed in the name of Christ. Take off your glasses." He took them off and blinked. "Do you see now?" He was wary of disappointing me. "I'm sorry . . . it's still blurry." He walked away puzzled, though there was no puzzle there really, beyond his lack of faith.

HADATH EL JEBBEH

The first girl wore black. The second girl wore black. The third, who showed us our rooms, wore black. Later we found out that a man had died the previous day. The woman down at the café wore black, and everyone in the village. Everything closed early. The bar, called Adrenaline, wasn't open at all. There were white streamers fluttering across the roads, for the dead man, white flags here and there.

I lay rigid in my bed. I'm not easily spooked, but it was an old building and the air conditioner was vocal. The dead man sat in a corner of the room. I was not afraid of him (they say he was a good man), but I was afraid that—all superstition apart—my heart would trick itself into a fatal arrhythmia. The night would never end. I cowered under my blanket. The man who died had not wanted to die. This was his protest.

The next morning, leaving the village, I saw the villagers all in black filing into church.

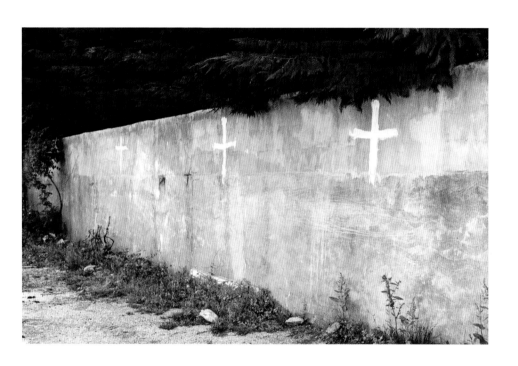

LUGANO

If the death of Christ was a ransom, Origen asks, to whom was the ransom paid? Not to God, who was the one paying. No, it was paid to the Devil, to whom humanity had become indebted, indentured, and enslaved.

Gregory developed the idea further, introducing the analogy of the hook. If Christ's humanity, his body on the cross, was the bait, then his divinity was the hook, on which the Devil finds himself caught. Gregory's analogy proved popular. But because it puts God in the role of a deceiver, it was also theologically worrisome.

TREASURE BEACH

The sea is abysmal. In the rain it was multiple grays, and on clear days of a jewel-like lucency, that interminable beauty of which neither poets nor civilians ever tire. But the sea is abysmal, the house of death. Above the regular practice of brutality, slavers, when chased, would simply toss the human cargo overboard. This is the terrifying scene depicted in Turner's painting *Slavers Throwing Overboard the Dead and Dying*.

The sea thrummed, it swelled. I could feel its mass and its sadness lifting the fragile boat. At the moment out in the open when we cut the engine and the silence took over, I could have wept.

Black bodies thrown into the sea.

But this death archive becomes the common language of the Black Atlantic. It is the sea that makes it possible for us to speak to one another. Our meaning-making is on the seabed. Our unity, as Brathwaite wrote, is submarine.

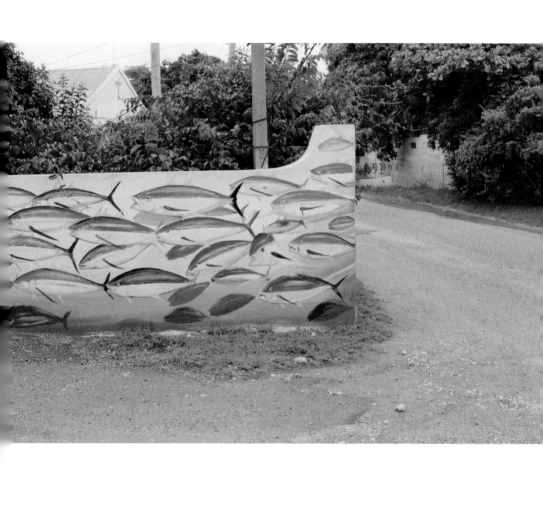

SÃO PAULO

Years later, I lost faith. One form of binocular vision gave way to an-
other. The world was now a series of interleaved apparitions. The thing
was an image that could also bear an image. If one of the advantages of
irreligion was an acceptance of others, that benefit was strangely
echoed in the visual plane, which granted the things seen within the
photographic rectangle a radical equality. This in part was why signs,
pictures, ads, and murals came to mean so much: they were neither
more nor less than the "real" elements by which they were framed. They
were not to be excluded, nor were the spaces between things. "We see
the world": this simple statement becomes (Merleau-Ponty has also
noted this) a tangled tree of meanings. Which world? See how? We
who? Once absolute faith is no longer possible, perception moves for-
ward on a case by case basis. The very contingency and brevity of vision
become the long-sought miracle.

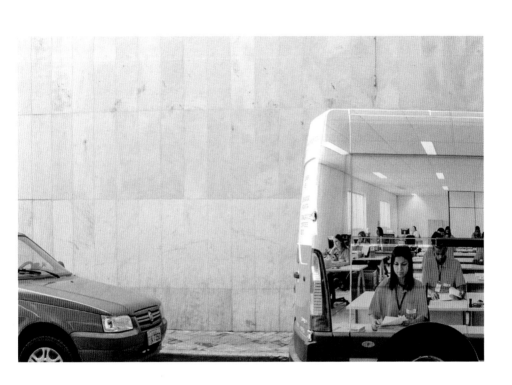

SEMINYAK

There is no surrender of beauty, only an effort to find beauty by going past the typical and arriving at the common. I do not love the travel pages. I look past them and go into the substratum of the visible environment. What I love about Bali is what I love about São Paulo, Nairobi, Seoul, and Reykjavik: the material evidence of human life, which goes on in spite of the world's enmity. In this search, an intense attachment to the beautiful remains. The sun pours itself all over the world and the world's things. Things are being built, or repaired, or broken. Things sit in the street, free of use. Things are on the verge of speech. Ladders rise, and angels invisibly ascend and descend.

Assemblages inhabit their own complexity and color. What I visit less often is what has been labeled beautiful ahead of time, what has been verified by the tourist board. I want to see the things the people who live there see, or at least what they would see after all the performance of tourism has been stripped away. I love these places that are not mine for the underground channel of perception by which they are connected, the common semantics of used space, the shock of familiarity, the impossibility of exact repetition.

FIGLINE VALDARNO

We had spent the day on roads linking small hilltop towns in Tuscany. Our ears wanted better radio reception. Our souls longed for heaven. We stopped near Figline Valdarno, and I wandered into a cemetery. "I saw a ladder, glimmering like gold / Lit by a sunbeam," wrote Dante from exile nearby, some 692 years ago.

CERN

We descend. A hundred meters below the earth are magnets cooled to a temperature lower than anything else on earth or in outer space. Down there, I feel myself an inhabitant of something called "the universe," as though I did not already live in the universe. I feel my body is made up of something called atoms, and for one giddy moment think: what if it all suddenly falls apart? We are mostly empty space, as the saying goes. I sense the trillions of neutrinos passing through me, the way the reading of a poem can suddenly intensify your awareness of the reality of the room. Looking at the ladders down in the ALICE tunnel, I feel myself climbing a ladder down into the dark of myself.

/CMM01

PITASCH

The meaning of the ladder for Jacob was positive. But he took fright, for he knew that a ladder can take you up and bring you down. That day in Pitasch, I walked down the steep alpine slope to the river Glenner, perhaps the most beautiful river I have ever known. The green of the evergreens that bordered it was of a profuse variety within a narrow chromatic range. There were gray and white rocks and stones along the bank. The air was still. The world was peace. The Glenner joins the Vorderrhein a few miles down, at Ilanz, and the Vorderrhein leads to the Rhein, which flows to the North Sea; but here, in the heart of the continent and near the Rhine's origin, the young fast shallow mountain river was slate blue with flashes of turquoise, and serried wavelets that crested white when the wind gusted. I got on my knees and drank directly from the cold river, then climbed back up the slope into the woods, and returned by the farmer's abandoned shed I'd passed on the way down. I was full of happiness, and was afraid, because I know a ladder can take you up as well as bring you down.

ZÜRICH

On tram No. 15 to Bucheggplatz, a woman sat in the seat in front of mine. She was in her late twenties or early thirties. Late afternoon light. Her hair was pulled up, and I could see her neck tattoo clearly. It was in two lines: a woman's name, a date. I wrote both down. Later, when I looked up the name, I found an old newspaper article: a woman of that name had died in a small town near Phoenix, Arizona, in 2007, and it had happened on the date in the tattoo. In the car that night, the article said, had been two other people, both of whom survived the crash, and both of whom, at that time, like the woman who died, were in their early twenties, a man, the article said, and another woman.

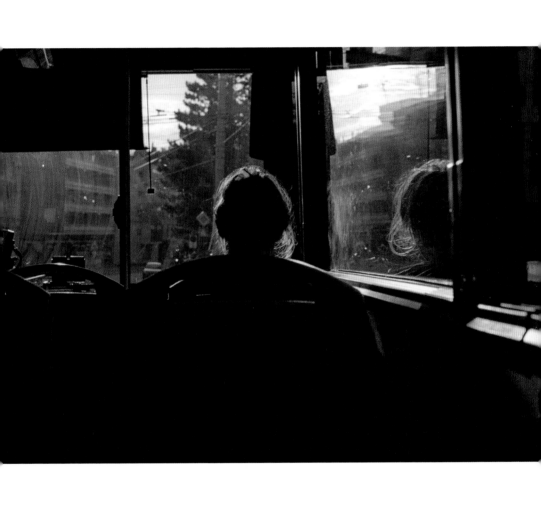

VENICE

The island is called the Giudecca, "the Jewry," though there's no proof that a Jewish community ever lived there. I've been walking for hours. I'm lost as usual in the precincts that other people call home. In Italy, I have a feeling that perspective does not exist in other places, only here. This notion is the influence of Italian painters, Piero della Francesca, Perugino, Uccello, the way their seeing has seeped into my skin.

While I am scanning this negative, at the very moment the scanner is whirring, I get an unexpected text message from A, who is a doctor: "One of my patients is a holocaust survivor. 93 year old. Still has PTSD and screams at night."

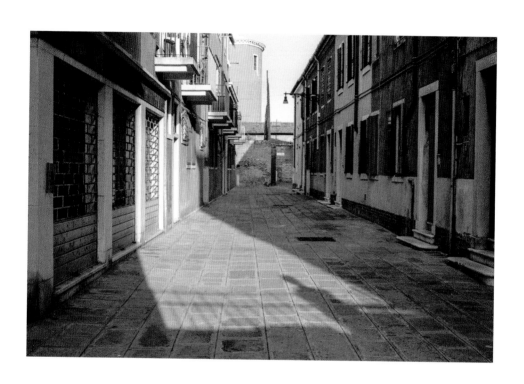

BIRMINGHAM

The introduction of "Alabama" has a discursive quality to it, like a black preacher's exhortations. And that is what it is: the keening saxophone line, built over rolling piano chords that are like a congregation's murmuring, is a paraphrase of the eulogy Martin Luther King, Jr., gave after a bomb exploded at the Sixteenth Street Baptist Church in Birmingham in 1963. "These children." The tracery of John Coltrane's line around King's halting grief-choked cadence. "Unoffending, innocent, and beautiful." McCoy Tyner's piano weeps. "Were the victims of one of the most vicious and tragic crimes ever perpetrated against humanity." Jimmy Garrison on bass. Elvin Jones on drums. These children.

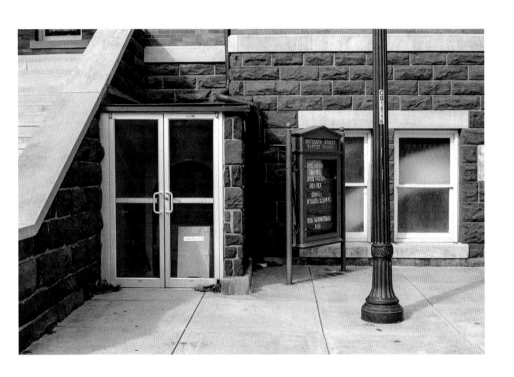

POZZALLO

We recover earrings, headphones, money (euros and dollars), family photographs, bracelets ("Jesus Loves Me"), shoes, handwritten letters, mobile phones, SIM cards, passports, and watches from the bodies of the drowned.

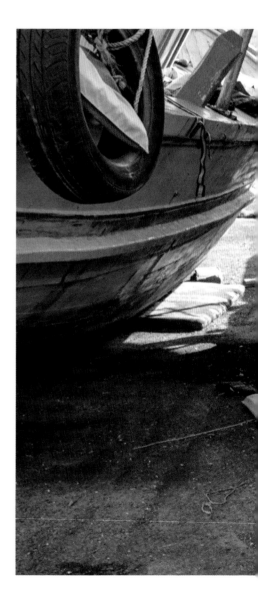

INTERLAKEN

The horizon (the limit) is horizontal. Where water meets land on the distant shore, where water meets the sky, is a level line. The human animal, the animal that stands, is vertical. And, standing, the human animal seeks out or creates other vertices. In its field of vision are trees, towers, and houses. Beyond these two axes, between them, is the mountain. The mountain is both vertical and horizontal. From the level line, the vertical line, and the triangle, are formed the elementary geometry of the landscape. The European languages, beginning with Greek, agree on the word for "horizon": horisontti, Horizont, orizzonte, horyzont, horizonte, horizon, горизонт, horisont.

PALM BEACH

The pile of earth at the time seemed constructive, and only later did it appear deathly. But soil seemed by then the only thing real in this sordid excess of simulacra. *Et in Arcadia ego.*

NEW YORK CITY

I follow her for one city block. Thirty seconds after the first photograph, I take a second. Against my will, and oblivious to hers. Then I lose her to the crowd—the mutual danger is defused. On Instagram, the ones who see what you saw are called your followers. The word has a disquieting air.

PARIS

In April 1981, at Sophie Calle's request, Calle's mother hires a private detective to follow Calle around, to report on her daily activities and provide photographic evidence of her life. The private detective does not know that the person he is following has paid to have herself followed. He thinks that of the three of them—himself, Calle, and Calle's mother—he knows the most in the situation. In fact he knows the least. She leads him around Paris, showing him her favorite places. He sees only what she wants him to see.

UBUD

The disaster is not that which is to come. The disaster is that which has already happened. The disaster is that what happened happened and that we survived. The disaster is to live in the aftermath of the disaster (it is "always already past," Blanchot says), the disaster that we survived by chance, and to insist at the same time that the disaster is yet to come.

To have survived the disaster and to forget that the disaster already happened, to look without recognition at the disaster, and to dramatize the disaster as though it is yet to come, is to become disastrous.

BROOKLYN

"Cornea" is Latin "cornu," horn. A horn for goring the visible. What you see you spear up with your eye. The word is related to "corner," in the sense that a horn is an extremity. "Retina," on the other hand, is Latin "rete," net, loose. "Reticulated" is from the same word. (I am full of grief because the world is unjust, because America kills black children at home and brown children abroad and blames them for their own deaths, because retired drone pilots are tormented by the ease with which they murdered innocents.) What you optically interpret, you gather up. Trident up front, the net behind. Or: hard gradient of cornea, retinal meadow. The horn stayed firm. The net came loose.

LUGANO

I had a dream last night. Lunch with Diana. There was no shadow of death at the meeting; only after I woke up did I remember that she had, in fact, died. Lunch was some sort of event, the royals were doing a fundraiser. Sunshine. Just us two at table. The waiter brought white wine, Vouvray. He had a nice suit on. I looked up at him: William. He was as he is now, grown, balding. It had been organized as a kind of joke: I could acknowledge that Diana was who she was, but had to pretend that the waiter wasn't William. (Also, in the dream, I was looking at William but was translating him as "Charles"; an oedipal element.) Lunch ended. I overcame my embarrassment and asked Diana for a selfie. She obliged. I used my iPhone: opened the camera app, flipped the direction of the lens. It didn't work. I tried again. It didn't work. Her smiling blue eyes became apologetic. An agonizing half hour passed as I fiddled with the accursed camera.

She was really sorry, she had to go. Her security detail had become impatient as well. We stepped outside, and, feeling a bit desperate now, I tried once again, with a friend's phone. No dice. Good God: I must have the selfie! But Diana had to go, and she went. For years now, my anxiety dreams have been full of cameras that don't work, mechanical faults, accidental light leaks, overexposures.

RAINBOW CITY

When Oedipus was finally told by the blind seer (the "blind" "seer") Tiresias all that had happened, he took out the long golden pins from his mother's garment and used them to blind himself.

N says, "Interesting that you say 'his mother,' and not 'his wife.'"

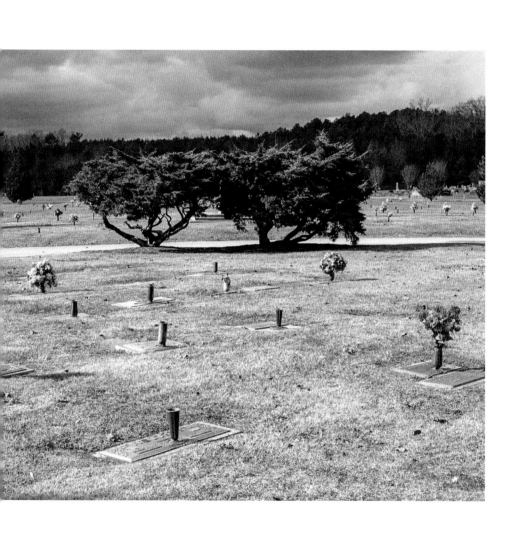

BEIRUT

A woman, small and old, maybe she's white, though it can be hard to tell here. "Parles-tu Français?" "Non." "Bititkallim 'arabi?" I shake my head. "You speak English?" "Yes." "You're from?" "America." "Ah, America"— she places a hand on mine—"I have two boys"—raises her other hand to her face—"both blind." I see the script. "If you can . . . just . . . one thousand . . ."

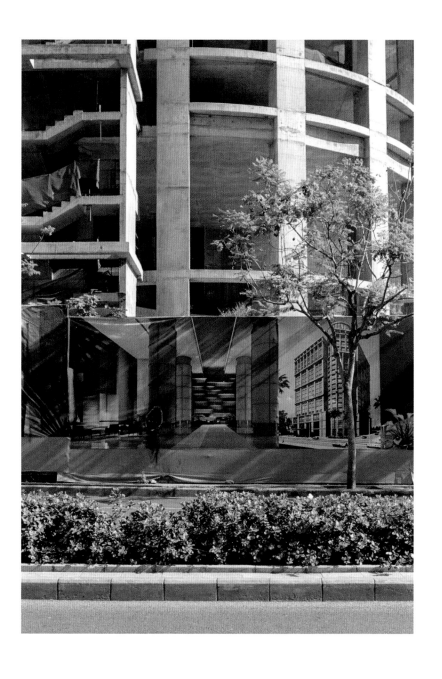

BROOKLYN

It is past eleven at night, and the Uber arrives three minutes after I call. It's something like a five-minute drive home. I make small talk with the driver, who's a middle-aged man. Not an American accent, but I can't tell precisely where he's from. "I have to go a bit slow," he says. Then, suddenly, I hear another voice: "They've put speed traps all along this road now." What's he on, speakerphone? I lean forward. There's someone in the passenger seat.

"I don't mean to frighten you, sorry," the voice says. "It's Saint Patrick's Day. I think it is just safer tonight if I am with him, in case of anyone drunk or something. Not that I have a weapon or anything. But they are less likely to make trouble if we are two." Then she adds: "I'm his wife." The streets are clear.

I ask where they are from. I can tell she doesn't like the question. "I'm from Brooklyn," she says. Then she softens. "Tunisia. What about you?" I could say Kalamazoo, I suppose, or Brooklyn too. "Ah," she says. "I'm African, just like you. Africa!" From. What is this word, "from"? Where were you born? Where do you live? Where do they have to take you in if you have to go?

Her husband is Lebanese. I still think I'm imagining the fact that she was sitting in the car for about three minutes before I knew she was there at all. There in the quiet dark. And then we've reached my place.

BROOKLYN

Southwest exposure. The room can be as bright as a field in winter, the sun pours in from early morning till late in the afternoon. It is my favorite room in the apartment. I go up to the windows and look out past the fire escape onto the row of houses across from mine. What I see is not the fronts of these houses but their backs; their backs face the backs of the houses in the row on which I live. This arrangement makes me think of canal-side houses, as though the space between the houses were now no longer a grid of ordinary New York City backyards, as though we were now in Amsterdam and were facing each other with water in between. And each day when the sun goes down and my room darkens and my neighbors' lights begin to twinkle on one by one, I begin to imagine their lives and their imaginations, in all their foreign languages, and I begin to imagine them imagining the lives lived in my apartment, and I begin to remember the shortage of bridges between them and me.

BLACK RIVER

In the cabin that morning, facing the open sea, I read Derek Walcott's *White Egrets*. His was the voice I wanted in my ear in Jamaica, alongside Ishion Hutchinson's, the surf of thought, the plashing cadence and concord of word and place.

Later in the afternoon, we went out into the open sea and by boat up to Black River, where aquamarine gave way to brown ("the strong brown god") and torrential sudden rain soaked me and my companions. The camera's seeing blurred in that wet. We'd gone to see crocodiles, and did, their thick individual threat close and perfectly still in the troubled water, regarding us, deciding we weren't worth the hassle.

What I did not expect was the egrets. They stocked a mangrove, flecked the trees' green with white. And in that crowd, as happens in photography, everything came to a teetering rest on one point: a single egret erect in profile on the right, a perfect emblem.

> The elegance of those white, orange-billed egrets,
> each like a stalking ewer, the thick olive trees,
> cedars consoling a stream that roars torrentially
> in the wet season; into that peace
> beyond desires and beyond regrets,
> at which I may arrive eventually . . .

BEIRUT

The flight was full. There was a man shouting in the aisle, something to do with the overhead luggage. The flight attendant attempted to calm him down. The man continued shouting, like when someone is so angry they want to die. Finally he stopped, and three babies on the flight began to cry.

The angry man, it turned out, was seated next to me. He had the middle seat, I had the aisle. It was a small plane. By the window was a woman who I presume was his wife. The babies kept crying; one of them, the loudest, seemed to be a newborn. The angry man scowled, spread his knees, and placed both his arms on the armrests, so that he took up quite a bit of room in my seat. His elbow dug into my side. I contorted myself to minimize contact. I was intimidated and promised myself I wouldn't speak to him. His wife, who wore a purple head scarf, brought out a plastic cup from which she fed him strawberries. Slowly he stopped scowling.

About halfway into the three-and-a-half-hour flight, when I had begun to doze, the angry man tipped a full cup of cold water on me. The water rose into the seat of my pants, ran down my leg, and soaked my socks. Silence. I took off my headphones and unbuckled my seatbelt. I went to get paper towels. I wiped the seat. The angry man, still holding his cup, looked at my seat as though something mildly peculiar, completely unconnected to him, had happened. He said nothing. I couldn't get my wet clothes dry. I was so furious that I refused to say a word to the angry man. I was so angry I wanted to deny him the satisfaction of seeing my anger. The angry man did not say sorry. He looked straight ahead. His wife looked out the window. We still had almost two hours left in the flight. I twisted to one side to avoid his elbow.

When we started to make our descent, two of the babies began to cry again. On arrival my clothes were still wet.

LISBON

The apartment was nice but, now that they had two daughters, too small for the family. She was a nurse and he was a doctor, both in their thirties. They found a new place, a house in another neighborhood, and began to make arrangements for a move. Then he died.

Death moves like dominoes in the dark. One unseen thing falls after another. She couldn't move from the apartment, she could no longer afford to move. The only move she made was out of their bedroom into a smaller room in the apartment. Their bedroom she left unchanged. The years passed. The money never quite came together. The dream of a house faded. She raised her daughters, they grew up and left home. There was no question of remarrying.

For more than thirty years she has lived in the apartment. Not for one night has she slept in what used to be their bedroom.

PIZ CORVATSCH

Persons unknown for reasons unknown placed a strip of black tape on the portrait of each black professor at Harvard Law School. The strip generally went from upper left to lower right, like a backslash, crossing out the right eye of each black professor, making of each a pirate or cyclops. We learn quite young the tricks of perspective: with a thumb you can make the moon disappear, with tarp you can blind a mountain, with a net capture a horn. But not really.

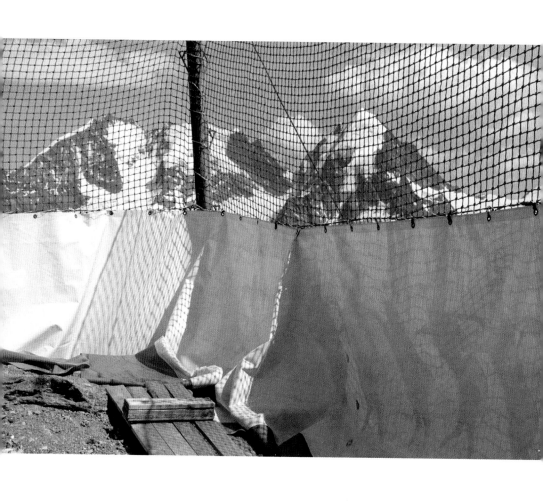

RIVAZ

If you walk along the northern lip of Lac Léman, between Montreux and Lausanne, you will see before you the lake's flat shine all across to Évian-les-Bains in France.

On steep slopes you wend your way past the wine-growing villages of Corseaux, Saint-Saphorin, Rivaz, and Chexbres, feeling in your legs the pleasure of a long walk along narrow old roads, some of which have new surfaces. We are a small group, we walk in solitude. There are people working in the vineyards. In one grove, a man harvests by hand, onerous-looking work. Farther along, in about half an hour, we will taste the white wines of Lavaux. Our mouths will be explored by the nectar of the landscape we have crossed. For now, below us are brown-roofed hamlets, and a pair of twin boys, around ten years old, come laughing up the road. "Do you live here?" "We have always lived here!" "Do you like it?" "We love it!" Their answers are in unison.

I rest at a concrete outcrop with a bunting of vintners' blue nets, a blue the same color as the lake. It is as though something long awaited has come to fruition. A gust of wind sweeps in from across the lake. The curtain shifts, and suddenly everything can be seen. The scales fall from our eyes. The landscape opens. No longer are we alone: they are with us now, have been all along, all our living and all our dead.

BRAZZAVILLE

Darkness is not empty. While preparing this book, I rescanned the negative of the boy by the Congo. "His eyes disappear," I had written. But all of a sudden, with slightly altered settings, I could now see his face, his eyes. Darkness is not empty. It is information at rest. Late in the nineteenth century, after hundreds of years of pressure by the European colonists, the villages in the interior, along the Congo River, began to succumb to the invaders. In response to this civilizational crisis, Mangaaka power figures were sculpted ever-larger, growing from their miniature sizes to the height of a man.

In each village, the Mangaaka was a sentry to ward off the oncoming collapse, "poised to spring into action," as scholars said, and "intensely reflective." The Mangaaka was full of potent medicine, with eyes of white metal enamel, irises of iron ore. This boy is double-visioned. He is looking out, looking outward, but here, poised at the edge of the crisis, he is also looking inward, looking in.

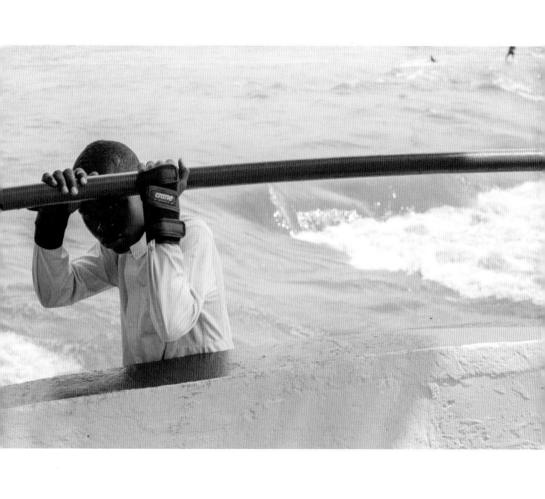

POSTSCRIPT: A MAP OF THE WORLD

In each place I have traveled, I have used my camera as an extension of my memory. The images are a tourist's pictures in this sense. But they also have an inquiring feeling to them and, in some cases, showed me more about the place than I might have seen otherwise.

I was born in the United States and moved back to Nigeria, my parents' country, as an infant. After finishing high school in Nigeria, I returned to the United States for university. With only a few exceptions—notably in the UK—this was the world I knew. In the last eighteen or so years, however, travel became a bigger part of my life. It began first with the journeys I undertook for my research as an art historian in training: to Germany, Austria, and Belgium. But later, after my books were published, I began to receive invitations to literary festivals and to teaching programs. If the place is interesting and I have the time, I go. I also traveled on vacation, or to see friends and family. Later still, I traveled on my own specifically to make photographs. Ten countries, twenty, thirty: the numbers mounted and "home" was now also in airport lounges and hotel rooms. Without my having intended it, the map of my movements was becoming a map of the world.

I am intrigued by the continuity of places, by the singing line that connects them all. This singing line I have responded to in this book in the form of a lyric essay that combines photography and text. Human experience varies greatly in its externals, but on the emotional and psychological level, we have a great deal of similarity with one another. Whether I was in the small town of Vals in Switzerland or in a high building overlooking the dwellings of millions of people in São Paulo, my constant thought has been the same: how to keep the line going. This proj-

ect came about when I began to match words to these interconnected images. The process, I found, was not so different from one of composing a novel: I made use of voices, repetitions (within the text, and from other things I have written), allusions, and quotations. This book stands on its own. But it can also be seen as the fourth in a quartet of books about the limits of vision.

To look is to see only a fraction of what one is looking at. Even in the most vigilant eye, there is a blind spot. What is missing?

Brooklyn
March 2017

Tivoli, U.S.
Rhinecliff, U.S.
Poughkeepsie, U.S.
New York City, U.S.
Queens, U.S.
Brooklyn, U.S.

Copenhagen, Denmark
Berlin, Germany
Wannsee, Germany
Nuremberg, Germany
London, United Kingdom
Paris, France

Vancouver, Canada
McMinnville, U.S.
Omaha, U.S.
Chicago, U.S.
Ypsilanti, U.S.
Fort Worth, U.S.

Lisbon, Portugal

North Charleston, U.S.

Palm Beach, U.S.

Sasabe, Mexico
Mexico City, Mexico

Black River, Jamaica
Treasure Beach, Jamaica

Lagos, Nigeria

Gadsden, U.S.
Rainbow City, U.S.
Birmingham, U.S.
Selma, U.S.

Brazzaville,
Republic of the Congo

São Paulo, Brazil

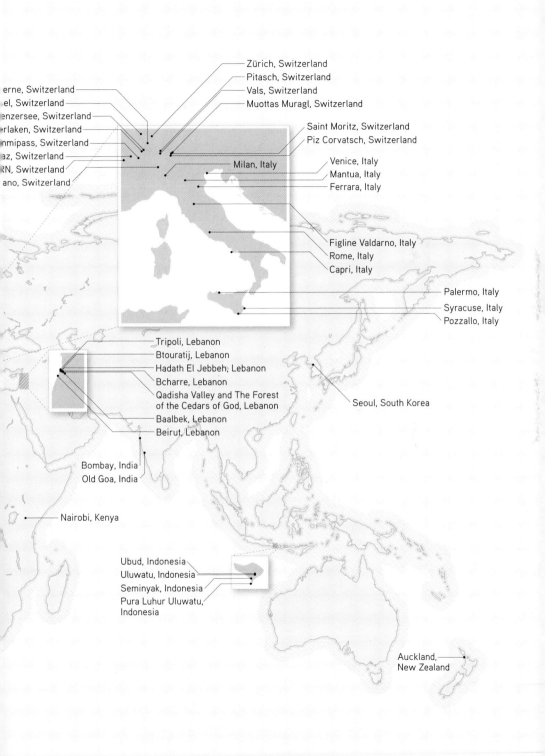

Zürich, Switzerland
Pitasch, Switzerland
Vals, Switzerland
Muottas Muragl, Switzerland

...erne, Switzerland
...el, Switzerland
...enzersee, Switzerland
...rlaken, Switzerland
...nmipass, Switzerland
...az, Switzerland
...RN, Switzerland
...ano, Switzerland

Saint Moritz, Switzerland
Piz Corvatsch, Switzerland

Milan, Italy

Venice, Italy
Mantua, Italy
Ferrara, Italy

Figline Valdarno, Italy
Rome, Italy
Capri, Italy

Palermo, Italy
Syracuse, Italy
Pozzallo, Italy

Tripoli, Lebanon
Btouratij, Lebanon
Hadath El Jebbeh, Lebanon
Bcharre, Lebanon
Qadisha Valley and The Forest
of the Cedars of God, Lebanon
Baalbek, Lebanon
Beirut, Lebanon

Seoul, South Korea

Bombay, India
Old Goa, India

Nairobi, Kenya

Ubud, Indonesia
Uluwatu, Indonesia
Seminyak, Indonesia
Pura Luhur Uluwatu,
Indonesia

Auckland,
New Zealand

PHOTO INDEX

ACKNOWLEDGMENTS

It is impossible to name everyone who helped make this book possible, but I'd like to acknowledge the special contributions of the following:

Beth Adams, Ade Adepoju, the Akisanyas, Elizabeth Angell, Katie Assef, Marina Astrologo, Jin Auh, David Bajo, Amy Barrette, Nilanjana Bhattacharjya, Elise Blackwell, Tracy Bohan, Chris Boot, Lee Brackstone, Andrea Canobbio, Finn Canonica, Michael Chabon, Wah-Ming Chang, David Chariandy, Angela Chen, Ken Chen, Giovanni Chiaramonte, Amy Conchie, Alessandra Coppola, Christie Davis, Kwame Dawes, Karen Pereira de Andrade, the Pereira de Andrades, Reshmi Dutt-Ballerstadt, Joana Reiss Fernandes, Elisa Gabbert, Fran Gennari, Thelma Golden, Gioia Guerzoni, David Alan Harvey, Miriam Hefti, Justine Henzell, Florian Höllerer, Andy Hsiao, Siri Hustvedt, Ishion Hutchinson, Alex Ives, Vijay Iyer, Anna Jäger, Vera Kaiser, Magda Kapa, Sumayya Kassamali, Teresa Cigarroa Keck, Roberto Koch, Karsten Kredel, Amitava Kumar, Colette LaBouf, Alyssa LaGamma, Hyeon-seo Lee, Alain Mabanckou, Pejk Malinovski, Alessandra Mauro, Caitlin McKenna, Joel Meyerowitz, Siddhartha Mitter, Antonio Monda, Beatrice Monti, Maria Nadotti, Thyago Nogueira, Valentina Notarberardino, Marie Noussi, Adewunmi Nuga, Edna O'Brien, the Oguntuyos, the Onafuwas, Michael Ondaatje, Diego Orlando, Ladan Osman, Rostom Pasha, Beth Pearson, Thomas Rohde, Kathy Ryan, John Ryle, Ayesha Saldanha, Andrés Sandoval, Bernd Scherer, Gesa Schneider, Stephen Shore, Jake Silverstein, Linda Spalding, Sieglinde Tuschy, Juliana Vettore, Ayelet Waldman, Alex Webb, Rebecca Norris Webb, Sasha Weiss, Connie Young, and Tony Young.

ABOUT THE AUTHOR

TEJU COLE was born in the United States in 1975 and raised in Nigeria. He is the author of *Blind Spot*, *Known and Strange Things*, *Every Day Is for the Thief*, and *Open City*. He has won the PEN/Hemingway Award, the Internationaler Literaturpreis, the Rosenthal Family Foundation Award for Fiction from the American Academy of Arts and Letters, and the New York City Book Award. He has been short-listed for the PEN Open Book Award and the National Book Critics Circle Award. In 2015, he won the Windham-Campbell Prize and a United States Artists Fellowship. His photography has been exhibited in India, Iceland, Italy, and the United States. He is the photography critic of *The New York Times Magazine*, where his "On Photography" column was a finalist for a 2016 National Magazine Award and was recognized with a 2016 Focus Award for excellence in photographic writing from the Griffin Museum of Photography.

tejucole.com

Instagram.com/_tejucole

ABOUT THE TYPE

This book was set in Aaux Pro, a typeface created in 2002 by Neil Summerour for the T.26 Type Foundry in Chicago. A Georgia-based type designer and lettering artist, Summerour expanded the Aaux family in 2009 for his Positype Foundry. Aaux's clean and straightforward design lends itself to text as well as display, and its popularity as a twenty-first-century sans serif can be attributed to its versatility.